IMAGES
of America

TULSA
CHRISTMAS PARADE

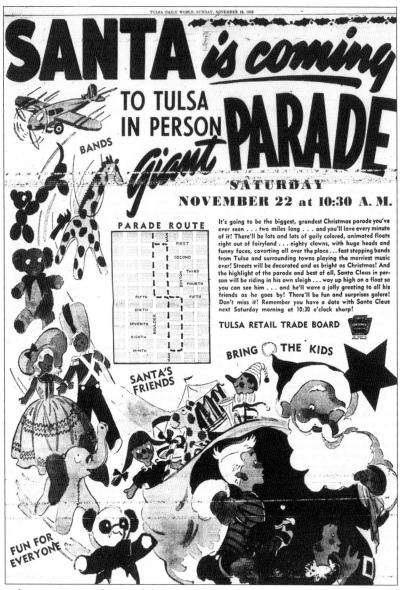

This is an advertisement and map of the parade route from page 20 of the *Tulsa Daily World* on November 16, 1952. *Tulsa World* was one of the main sponsors of the Tulsa Christmas Parade in its early years. (Courtesy of *Tulsa World*.)

ON THE COVER: This image from the parade on November 26, 1949, captures many of the elements that have been quintessential to the Tulsa Christmas Parade over the last nine decades. The angle of this shot shows South Main Street in a view looking north from West Sixth Street and captures many of the structures along the route, like the Mayo and Sinclair Buildings, and retailers that helped form the parade in its early years, such as Vandevers and Brown-Dunkin department stores. Here, Santa is seen waving to the crowds; a band marches merrily behind Santa's float; bright decorations are hung across the street; and crowds of children are mesmerized by Santa. (Photograph by Howard Hopkins, courtesy of Dewey F. Bartlett Jr.)

IMAGES
of America

TULSA
CHRISTMAS PARADE

Jessica Gullo
Foreword by Sen. Jim Inhofe

ARCADIA
PUBLISHING

Published by Arcadia Publishing
Charleston, South Carolina

Printed in the United States of America

Library of Congress Control Number: 2017942315

For all general information, please contact Arcadia Publishing:
Telephone 843-853-2070
Fax 843-853-0044
E-mail sales@arcadiapublishing.com
For customer service and orders:
Toll-Free 1-888-313-2665

Visit us on the Internet at www.arcadiapublishing.com

*This book is dedicated to the millions of children, in age
and spirit, who have and will continue to enjoy the magical
delights of the Tulsa Christmas Parade each year.*

CONTENTS

FOREWORD

For over 90 years, the city of Tulsa has commemorated the Christmas season with a Christmas parade downtown. The first parade, featuring only Santa and a few marching bands, was held in 1926 and drew a crowd of over 50,000 people—the largest crowd in Tulsa since wartime. While the parade has grown and changed over the years, the reason for the parade has not—the community of Tulsa coming together to celebrate the birth of Jesus Christ.

I have participated in the parade for around 40 years—since I was mayor of Tulsa. Riding my horse in the parade is one of my favorite parts of the Christmas season. Unfortunately, a few years ago, forces of political correctness removed the word "Christmas" from the event. When I received the call asking me to participate, as I had every year, I had to decline. If Jesus was not invited, neither was I.

Christmas is not a holiday that can be sugarcoated for the sake of political appeasement. So while Christmas is a day that serves as an important and emblematic declaration of peace on earth and goodwill toward all, it is first and foremost about the birth of Christ. This declaration shall never be diluted to a "winter" or "holiday" celebration. Whether or not a person recognizes the significance of Jesus Christ, the message of Christmas for peace on earth lies in the heart of all humanity.

I am proud that Tulsa has chosen to return the word "Christmas" to the name of the parade, embracing the true meaning of peace and bringing folks together during the Christmas season. The Christmas parade in downtown Tulsa is a wonderful tradition that contributes to the city's rich history. While the parade has grown and seen many changes over the years, it truly is the spirit of Christmas and the love of Jesus Christ that is cause for celebration and always will be.

—Sen. Jim Inhofe

ACKNOWLEDGMENTS

This book would not have been possible without the help of several people. First, I would like to thank Kenny and Vickie Burkett for their dedication in continuing the tradition of the Tulsa Christmas Parade and to the employees of American Waste Control, Inc., who put in countless hours each year to create the magic of the parade. Secondly, much appreciation goes to former Tulsa mayor Dewey F. Bartlett Jr. for saving the history of the parade, as well as much of Tulsa, by preserving the collection of Tulsa photographer Howard "Hoppy" Hopkins. Next, I would like to thank Sue Bunday from the Tulsa Christmas Parade Committee for her expertise in parades and assistance with editing. I would also like to thank Caroline Anderson and the team at Arcadia Publishing for being flexible and allowing me to have the time required to find the images that were imperative to tell the story of the Tulsa Christmas Parade. Thanks also go to Tom Gilbert with *Tulsa World* and Ian Swärt with the Tulsa Historical Society & Museum for their assistance in providing images for this book. And, finally, a thank-you goes to Jim Moore for the inspiration to preserve the history of the Tulsa Christmas Parade in a book for all to enjoy.

INTRODUCTION

The first Christmas celebration in Tulsey Town, Oklahoma, in 1883, was on a chilly and icy night. But the spirit of Christmas was warm and abundant, and all of the residents of the small town were in attendance. There was one Christmas tree decorated with strings of popcorn, candles, and bright paper. Men, women, and children—those who lived in town, those recently moved to the area, and those from Native American tribes also living there—all shared the night and sang joyous Christmas carols together, and at the end of the night, there was even a visit from Santa passing out presents to each of the children. One of the founders of Tulsa, J.M. Hall, was dressed up as Santa to surprise the children, and he remembered it as a night of "happiness and good cheer of the Christmas Season."

Over the next 40 years, the spirit of community and Christmas continued to grow as the young and small but rapidly developing boomtown was quickly expanding, drawing people from all over the country and even the world to the new town with hopes of new beginnings. By the 1920s, several of the prominent businessmen that had worked for many years to build Tulsa from that small town to the thriving city it was becoming came together with an idea to continue to unite the community and spread Christmas cheer. At their helm was Gary Vandever, one of five brothers who owned and operated the department store Vandevers for almost 90 years in Tulsa. Their goal was to create a Christmas spectacle for the children of Tulsa that included a visit from Santa himself. A parade was planned, and one of the men in the group, Charles Page, arranged for four live reindeer to be shipped in by railway and accompany the merry man.

Tulsa had many occasions for celebration and parades in its early days due to the discovery of oil nearby, which lead to a very fast increase in population, business, and wealth. During the parade's beginnings, Tulsa was considered the "Oil Capital of the World," and the population grew very quickly. As a result, by 1926, the first year of the Christmas parade, the town of Tulsa was well accustomed to filling every empty space and crowding together to watch as elaborate parades wound through the streets of downtown. Just three years earlier, the first International Petroleum Exposition had been held there, culminating in a large parade attended by thousands of people. A local paper, the *Tulsa Tribune*, helped promote the first Christmas parade by publishing telegrams from Santa in the weeks leading up to the parade, updating all of Tulsa on the progress of his trip. Along the way, he stopped in Seattle, had to repair his sleigh, and tended to the reindeer. All of this promotion generated much excitement for the parade, and on the evening of December 4, 1926, Santa and his four reindeer touched down in Owen Park, just northwest of downtown. From there, they set out along the route, greeted by thousands of people cheering and singing "Jingle Bells."

Throughout the early years of the parade, the committee planned several grand displays, and the parade quickly became an extremely popular event that everyone looked forward to each year. Fresh off Charles Lindbergh's famous flight earlier that year, in 1927 the committee took advantage of this latest fad and continued with the tradition of an extravagant visit from Santa

with a candy-cane striped plane that was custom built specially for the festive fellow to fly in on. In 1930, Santa outdid his original visit from 1926, this time bringing 10 live reindeer with him. In 1933, Miss America was the guest of honor and "royal host." Because of these grand beginnings, the Tulsa Christmas Parade has a unique history of being a highly attended parade, with over 50,000 people at the first one. At that time, Tulsa was still a growing city with a population of around 100,000. Parade attendance grew each year, and by the late 1940s and into the 1950s, when Tulsa's population was around 180,000, the parade annually drew upwards of 200,000 people, jamming the downtown streets to watch the parade and then go Christmas shopping. Many downtown retailers such as Froug's Department Store and Brown-Dunkin took advantage of these enormous crowds and planned special sales to draw shoppers in. They also set up a Toyland with Santa that the children could visit after the parade. Many years, the streets would not be cleared until hours after the parade had ended.

In the past 90 years since that first parade, the Tulsa Christmas Parade has continued to draw thousands of people each year. Over the years, the parade has been known by several different names, sometimes slightly changing from year to year. Some of the titles of the past 90 years include the Santa Claus Parade, Tulsa World's Santa Claus and Balloon Parade, the Children's Parade, the Yuletide Pageant, the Parade of Lights, and the Tulsa Christmas Parade, now the official title. But no matter the name, the goal has always been the same—to invite all people from Tulsa and the surrounding communities to come together with the common goal of celebrating Christmas. The first parade was held at night, and throughout the first several years, it went back and forth from a nighttime parade to a daytime parade. By the 1940s, it was mostly held during the day, but in the 1980s, when the parade's name was changed to the Christmas Parade of Lights, it was moved back to the after-dark hours to let the festive lights shine brightly.

The route of the parade has changed many times over the years, partly due to the continued growth and expansion of downtown Tulsa. But even through all the changes, with many twists and turns and revisions to the route, the parade has continued to include the same stretches of South Boston Avenue and still marches down this iconic path to this day. In the heart of downtown Tulsa, South Boston Avenue was one of the first streets in town, bustling with homes, stores, churches, and schoolhouses in its earliest days. It is also home to many of Tulsa's earliest skyscrapers, including several architectural masterpieces erected during the Art Deco era of the 1920s and 1930s. As a result of the immense growth and abundance of money Tulsa saw in its early days due to the oil industry, Tulsa grew to be home to one of the largest collections of Art Deco buildings in the nation, and the Tulsa Christmas Parade has used these stunning structures as a backdrop throughout its history, many of which are well documented in the photographs in this book. These buildings tell the story of Tulsa's history. Unfortunately, some are no longer standing, such as the Majestic Theater on South Main Street, which was lost to a fire in 1973. Thankfully, the theater and many of the other buildings lost are forever immortalized in the photographs of the parade throughout the years, and their beauty can continue to be enjoyed for years to come.

Tulsa has seen many festivals and events in its history and had many unique parades over the years, but the Christmas parade continues to be one of its longest-standing traditions and is still running strong. From its beginnings over 90 years ago, the Tulsa Christmas Parade has been a community event centered around bringing the people of Tulsa and its surrounding areas together. Today, the men and women of the committee that run the parade continue to work hard to ensure that each year, nearly a century after the first celebrations began, Tulsa continues the tradition of gathering families together to watch the annual Christmas parade light up downtown Tulsa.

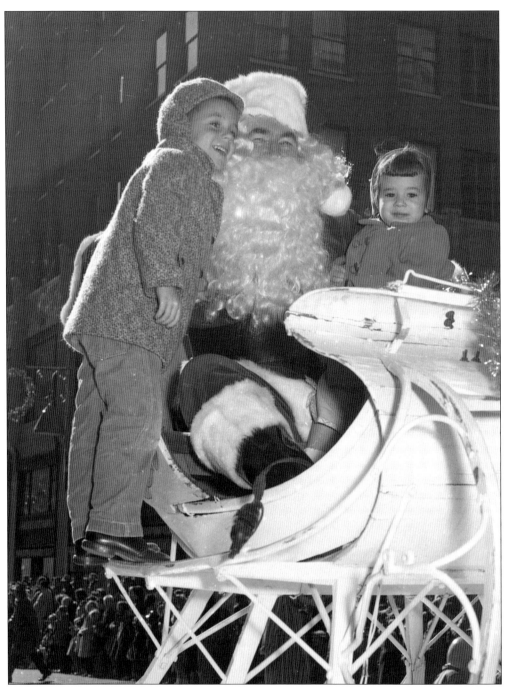

Four-year-old David Brown and his sister Rebecca both hope they are on Santa's nice list as they lean in to tell the jolly fellow what they want for Christmas at the 1956 parade. Behind them is the Philcade Building at 501 South Boston Avenue, one of the many Art Deco masterpieces in downtown Tulsa that have provided a breathtaking backdrop for the Tulsa Christmas Parade over the last nine decades. (Photograph by Howard Hopkins, courtesy of Dewey F. Bartlett Jr.)

One

ALL I WANT FOR CHRISTMAS IS A PARADE

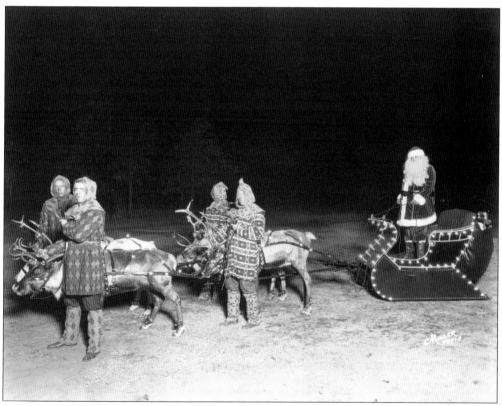

On December 3, 1926, over 50,000 people welcomed Santa and his four live reindeer to Tulsa at Owen Park, just northwest of downtown. The procession wound through the streets of downtown Tulsa for the first Christmas parade, called the Santa Claus Children's Parade. The procession came to an end at the courthouse at West Sixth Street and South Boulder Avenue. Seen here is Ook Wat (front right), the Eskimo keeper of Santa's live reindeer. (Photograph by Edward M. Miller, courtesy of Tulsa Historical Society & Museum.)

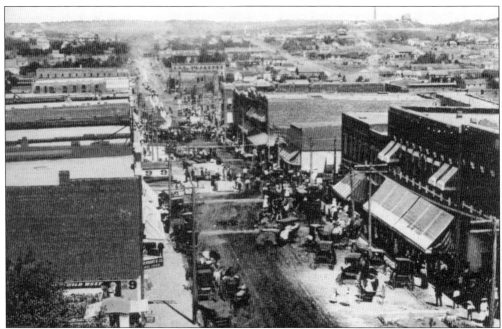

In 1905, just four years after the discovery of oil in Red Fork, another oil field was discovered in Glenn Pool, and Tulsa was quickly transforming from a small, dusty cow town to a bustling boomtown. Here, one of the first parades in Tulsa proceeds south down Main Street from Brady Street as people celebrate the Fourth of July. (Courtesy of Tulsa Historical Society & Museum.)

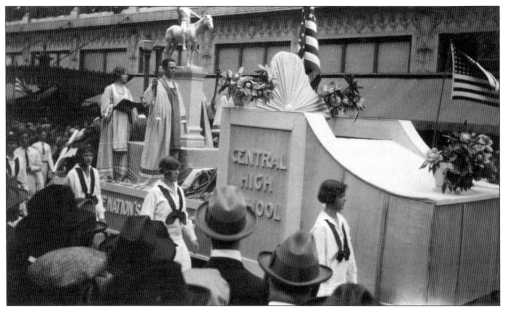

Seen here around 1924, Central High School has gleefully participated in many of Tulsa parades. Established in 1906, the oldest high school in Tulsa was originally located at East Fourth Street and South Boston Avenue, an intersection that has been on the route of the parade since its induction in 1926. (Courtesy of Tulsa Historical Society & Museum.)

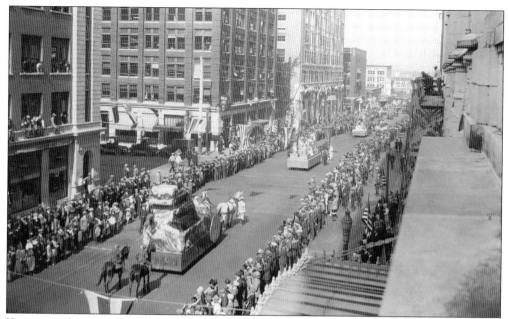

Known as the "Oil Capital of the World," Tulsa, Oklahoma, was the perfect location for the International Petroleum Exposition (IPE), held from 1923 to 1979. The IPE attracted visitors from all over the world and was one of the largest trade shows ever in existence. The first year was a tremendous success, and despite heavy rains the entire week, the event had a carnival-like atmosphere, complete with a parade headlined by King Petroleum and Queen Petrolia. (Courtesy of Tulsa Historical Society & Museum.)

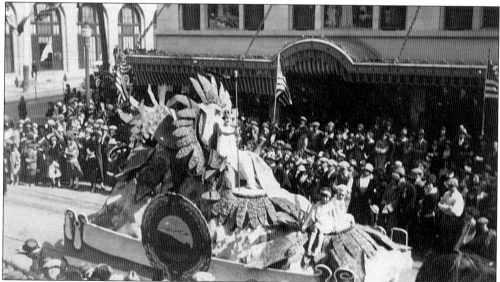

In 1924, the IPE was moved to the fairgrounds, and a Princess Contest was held with entries from many states to attract more visitors. A special parade was planned and held in downtown going down South Boston Avenue. Each contestant was presented on a custom-built, fancy float, complete with royal attendants to ride along with each princess. People packed the streets to get the best view. The winner of the contest was Miss Kansas, Ramona Marcella Treese, of Winfield, Kansas. (Courtesy of Tulsa Historical Society & Museum.)

Gary Vandever, one of five brothers who ran the successful department store Vandevers, which was first opened in 1904 and closed in 1991, was instrumental in bringing the first Christmas parade to Tulsa. The Vandever family immersed themselves in the local community and supported many charitable causes throughout their tenure in Tulsa. Seen above is a truck decorated by the Vandevers for an unidentified parade in 1911. Below is a vehicle decorated with flowers, entered as a float in the Rose Carnival Parade, held on May 15, 1927. The original Vandevers department store building at 16 East Fifth Street still stands with the original sign and was converted to Vandever Lofts in 2014. (Above, courtesy of Tulsa Historical Society & Museum; below, photograph by Alvin Krupnick, courtesy of Tulsa Historical Society & Museum.)

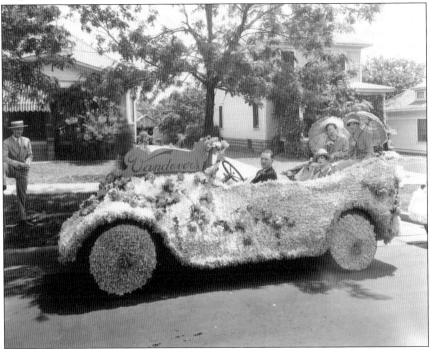

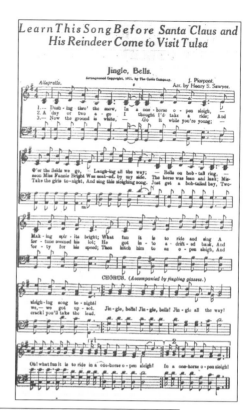

In 1926, several of the prominent businessmen in Tulsa wanted to create a spectacular show for the children of Tulsa. Charles Page, along with Gary Vandever, planned to bring Santa and his reindeer in from the North Pole to visit Tulsa. In the weeks leading up to the parade, several telegrams from Santa were published in the *Tulsa Tribune* to update Tulsa on his progress. In preparation for the big night, the *Tulsa Tribune* also published the sheet music for "Jingle Bells" and encouraged all of Tulsa to learn the song and clip the music out of the paper and bring it to the parade to ensure the warmest welcome for Santa and Blitzen, Dunder, Dasher, and Vixen. The newspaper also collaborated with the local schools and had practice sessions for the children to learn Santa's "national song." (Both, courtesy of *Tulsa World*.)

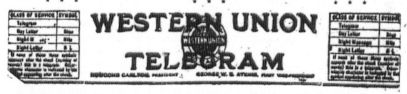

Igloo Being Built Here in Preparation For Santa's Visit; Traveling Fast, And Will Spend Night in Denver

★ ★ ★ ★ ★ ★ ★ ★ ★

T12WU A 38 BLUE

BOISE IDAHO NOVEMBER 30 1926

ROBERT FARRIS

CARE THE TULSA TRIBUNE TULSA OKLAHOMA

WE ARE MAKING GOOD TIME AND EXPECT TO BE WITH YOU SOON.

HAVE ALL THE LITTLE BOYS AND GIRLS WATCH FOR MY MESSAGE

TELLING JUST WHEN TO EXPECT ME. REINDEER ARE IN GOOD

CONDITION AND LIKE YOUR COUNTRY FINE.

(Signed) SANTA CLAUS

In Santa's honor, a parade was planned for the evening of December 3, 1926, and an igloo was built at Tulsa County Courthouse, at West Sixth Street and South Boulder Avenue, to accommodate Santa and his reindeer. In the weeks after the parade, Santa and his reindeer were special guests at several events, and the reindeer were paraded through residential areas as Santa bestowed children with gifts and candy. Unfortunately, likely due to the climate, the reindeer did not fare well in Tulsa. Dasher and Dunder both died before Christmas, with Blitzen following by January 1, 1927. The lone survivor, Vixen, eventually made his home at the Sand Springs Zoo. (Courtesy of Tulsa Historical Society & Museum.)

In 2016, the 90th year since the first parade, the volunteers that run the Tulsa Christmas Parade committee proposed honoring the nine decades of the parade with a theme of "Christmas Cheer of Yesteryear"—all entries represented one of the decades of the previous 90 years. American Waste Control, Inc., presenting sponsor of the parade, paid homage to the first year of the parade with a float built depicting Owen Park and a golden reindeer. (Photograph by Stephanie Phillips, courtesy of Tulsa Christmas Parade.)

Two

IT'S BEGINNING TO LOOK A LOT LIKE CHRISTMAS

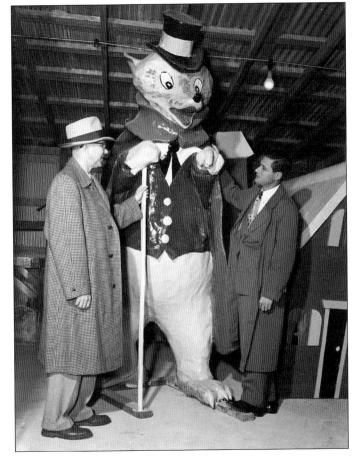

Preparations for the parade start long before the big day. Floats are designed and then built; costumes are planned and created; and tinsel, garland, and lights galore are hung downtown to set the mood for a festive event. Here, Curtis C. Chapman (left) and Bill Rayson (right), members of the Publicity and Promotion Committee, pose with the Wolf for a Little Red Riding Hood float for the 1951 parade. (Photograph by Howard Hopkins, courtesy of Dewey F. Bartlett Jr.)

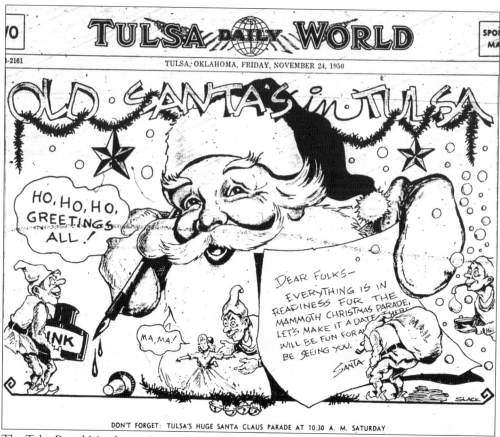

The Tulsa Retail Merchants Association sponsored the parade from the 1930s to 1956 as a way to draw crowds downtown for the Christmas shopping season. Large promotions were printed in a local newspaper, *Tulsa World*, and many downtown retailers ran special sales just for the parade; *Tulsa World* helped promote the parade with articles stirring interest in the weeks leading up to the parade. The parade committee also built elaborate floats. Above is an advertisement on the front page of *Tulsa World* from November 24, 1950. Below, the Dream Train float was built by volunteers and can been seen here the morning of the parade on November 25, 1950, as a volunteer stands behind the train and demonstrates how it will be brought to life during the parade. (Above, courtesy of *Tulsa World*; below, photograph by Howard Hopkins, courtesy of Dewey F. Bartlett Jr.)

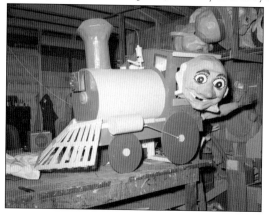

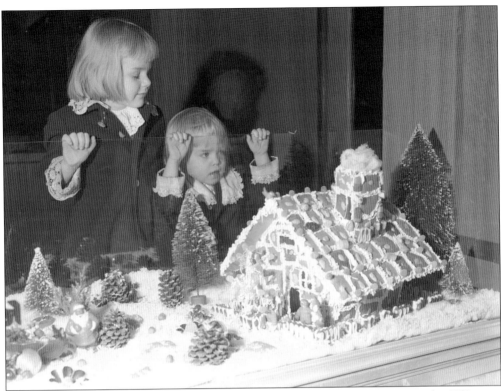

Above, two young girls are seen admiring a window display at a department store. In the 1950s, over 200,000 people from Tulsa and all over Oklahoma came to the parade each year. The parade kicked off the Christmas shopping season, and downtown stores such as Froug's, Vandevers, and Brown-Dunkin put on elaborate displays to attract shoppers after the parade. Most stores stayed open until 8:30 p.m. to give shoppers plenty of time to pick out Christmas gifts for friends and family. As seen below, inside Brown-Dunkin, crowds were so large at times that one department store owner told local newspaper *Tulsa World* they had to close their doors to allow customers to finish before they could let more in. (Both, photograph by Howard Hopkins, courtesy of Dewey F. Bartlett Jr.)

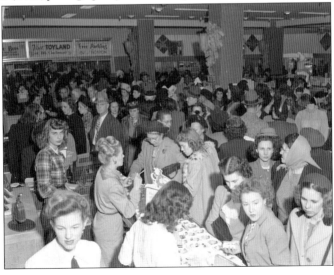

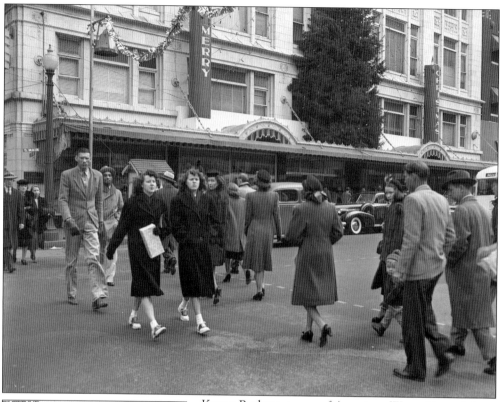

After the great Christmas Parade Saturday and from

Now Until Christmas Visit the

Brown-Dunkin

Santa Claus Toyland

Home Store, 8th & Cinn.

Free Gifts
to all the children

To each child that visits our Toyland Saturday, Nov. 17, a Santa's Magic Wishing Ring will be given FREE!

If you haven't visited our Toyland in the past years, you certainly won't want to miss it this year! Famed for its variety and huge selection, Toyland is chocked full of the latest mechanical devices as well as the "usual" toys that are so dear to a child's heart! Bring in your child to see this fabulous "wonderland" . . . it will be a treat for you, too!

Kenny Burkett, owner of American Waste Control, Inc., presenting sponsor of the parade since 2014, remembers the days when downtown was a bustling mecca of the budding metropolis of Tulsa. "People would flock downtown to the stores and shop and go to the parade. In those days most of the retail was still downtown and hadn't spread to other areas yet. Children would line the streets and sit on the curbs waiting for the parade while their parents shopped in nearby stores," Burkett recalls. Retailers such as Brown-Dunkin (later Dillard's), seen above in 1947, took full advantage of this. Brown-Dunkin held a special Santa Claus Toyland after the parade and offered free gifts to all the children who visited. Children had the opportunity to meet Santa in person, ride the train at the Fantasy Land, and then explore all the magical sights of Santa Claus Toyland after experiencing the fantastical sights of the parade. (Above, photograph by Howard Hopkins, courtesy of Dewey F. Bartlett Jr.; left, courtesy of *Tulsa World*.)

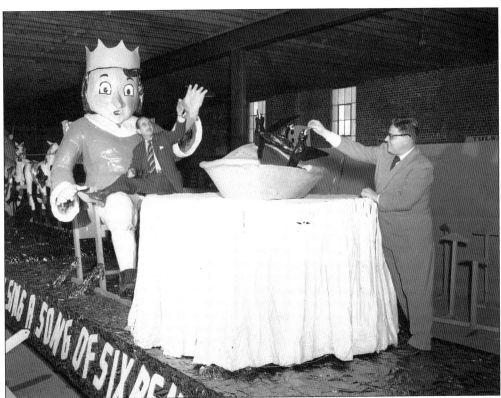

Above, general chairman Tom Lottinville (left) and Hal Pimsler (right), both members of the eight-person Retail Trade Board Parade Promotion Publicity Committee in 1950, show off the Song of Sixpence float by helping the four and 20 blackbirds escape from the pie. The two are in Santa's workshop, a secret and mysterious location, only reported as being "somewhere north of Tulsa" in the *Tulsa World*. Below, three men dressed in clown heads demonstrate how the platforms for floats are constructed over a vehicle, allowing the illusion of a true "float." These platforms were built to allow the driver's head to peak out in the middle of the float just enough to steer it. The construction seen here is on November 16, 1950. (Both, photograph by Howard Hopkins, courtesy of Dewey F. Bartlett Jr.)

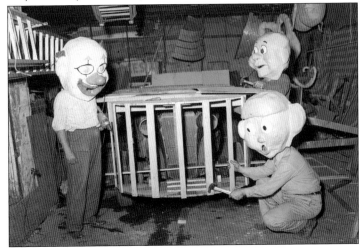

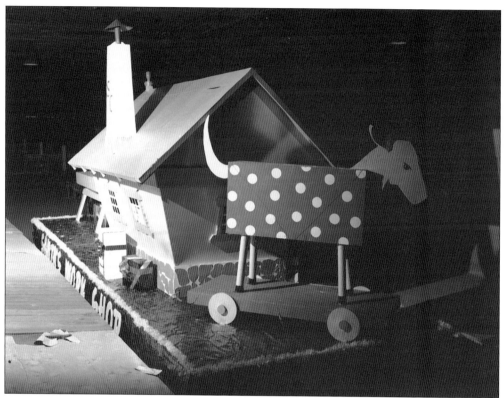

Above, Santa's Workshop float is shown in a photograph from November 16, 1950, just nine days before the parade, as the finishing touches are being applied to make it ready for the big day. Below, the float is seen proceeding down South Main Street the morning of the parade. The staging area for all parade entries was marked off with paint the Friday night before to avoid any confusion on Saturday morning. (Both, photograph by Howard Hopkins, courtesy of Dewey F. Bartlett Jr.)

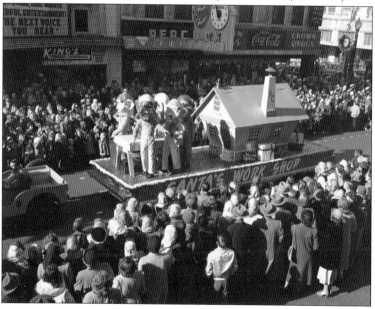

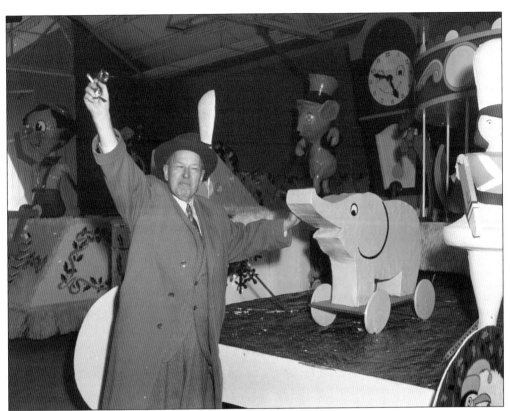

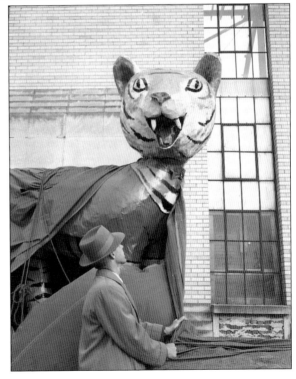

Above, W.G. Skelly, founder of Skelly Oil, shows off an elephant for the Merry-Go-Round float for the 1951 parade. The float included five live animals—a moose, a giraffe, a hippopotamus, a lion, and a kangaroo—interspersed with wooden ones. At right, a large feline fairy-tale figure is unveiled for a photo opportunity on November 16, 1950. A total of 53 units, including floats, large animal characters, and inflatables, made up the Yuletide Pageant in 1950, with preparations starting months before to ensure all floats were ready for lineup by 9:30 a.m. on November 25, 1950. (Both, photograph by Howard Hopkins, courtesy of Dewey F. Bartlett Jr.)

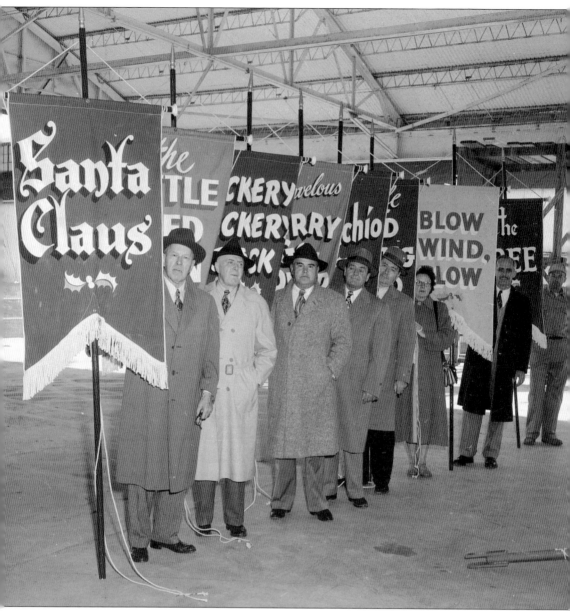

Members of the parade committee pose for a publicity shot and show off the new banners being debuted that year with the themes for floats in 1951. From left to right are W.G. "Mr. Oklahoma Santa Claus" Skelly; W.B. Way, president Tulsa Decorations and Parade Corp., sponsors of the pageant; Howard Fenton, out-of-town visitors' coordinator; Carl P. Flynn, parade marshal; Jack Eldridge, public relations; Juanita Meade, wardrobe mistress; Dallas Meade, float designer-producer; and George Shaw, co-designer and construction superintendent at Santa's mysterious Tulsa workshop. (Photograph by Howard Hopkins, courtesy of Dewey F. Bartlett Jr.)

At right, George Shaw models one of the 80 papier-mâché heads while Juanita Meade looks on. The committee made the last-minute decision to remove all papier-mâché head costumes and float pieces from the parade due to a forecast of rain and sleet predicted for the morning of the 1951 parade. Below, Bill Rayson (left) and Curtis C. Chapman (right) show off the new banners being debuted that year that would lead each float so the children would be able to see the names high above the crowd. In past years, the float names had been displayed along the sides of each float, preventing most children from seeing them. Two persons dressed as clowns join the men. (Both, photograph by Howard Hopkins, courtesy of Dewey F. Bartlett Jr.)

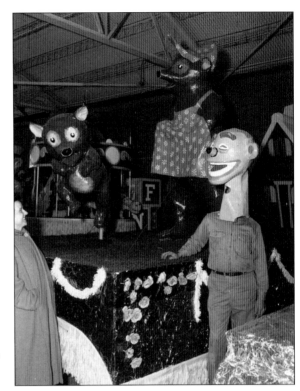

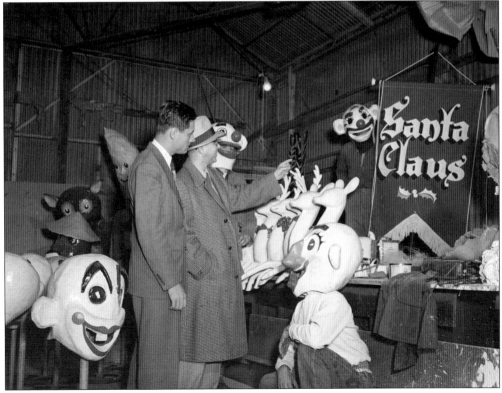

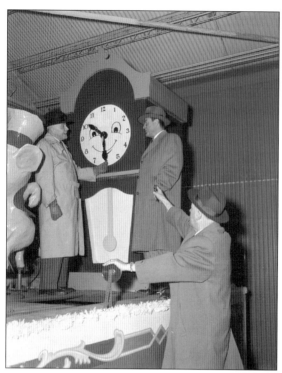

The morning of the parade on November 24, 1951, local paper *Tulsa World* reminded all of its readers to not be late for the parade with this custom version of a well-known nursery rhyme: "Hickory Dickory Dock, the mouse runs up the clock. The clock strikes half-past 10. The mouse runs down again. And Santa's Yuletide parade will begin." Parade committee members at left are, from left to right, W.B. Way, Carl P. Flynn, and W.G. Skelly. Below, the mouse for the float scurries to his spot for the parade. (Both, photograph by Howard Hopkins, courtesy of Dewey F. Bartlett Jr.)

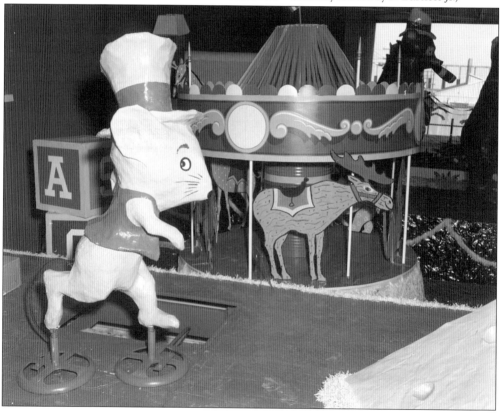

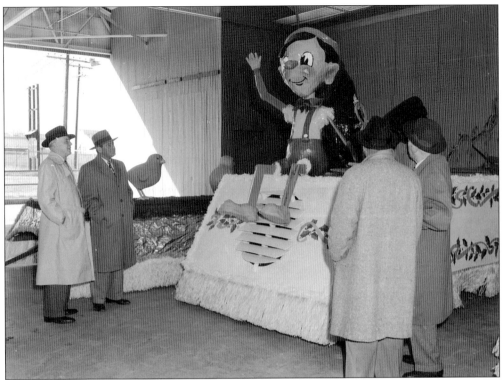

Above, from left to right, W.B. Way, Carl P. Flynn, Howard Fenton, and W.G. Skelly admire the 15-foot-tall Pinocchio perched on the end of his float at Santa's secret workshop four days before the parade. Thankfully, Pinocchio was made from hard materials and not susceptible to water damage from the rain and sleet forecasted for the morning of the parade, so he was able to wave happily to the crowds of nearly 250,000, a new record for attendance, at the 1951 parade. Below, thousands push in to get a better look at the long-nosed lad at the corner of West Fourth and South Main Streets. (Both, photograph by Howard Hopkins, courtesy of Dewey F. Bartlett Jr.)

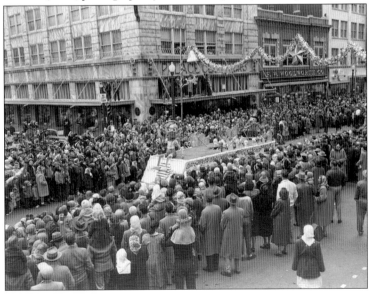

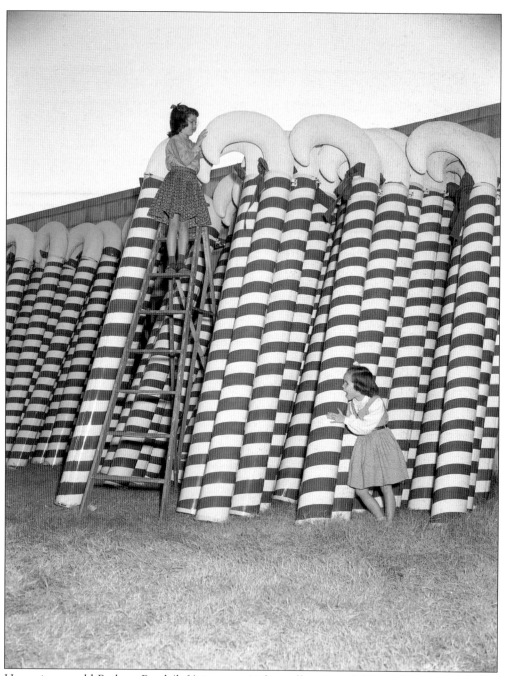

Here, six-year-old Barbara Boyd (left) inspects 11-foot-tall papier-mâché candy canes while her four-year-old sister Susan appears to be taste testing the colossal confections. Eighty-eight of the supersized sweets were designed by Dallas Meade, designer of floats and decorations for the parade committee, and were hung throughout the route for the 1954 parade. (Photograph by Howard Hopkins, courtesy of Dewey F. Bartlett Jr.)

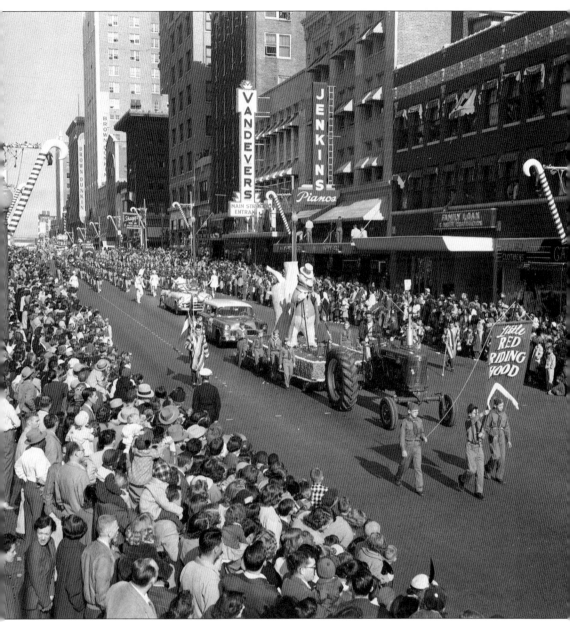

The oversized candy canes can be seen here on South Main Street as the Little Red Riding Hood float passes by with the marching band from Central High School following closely behind. (Photograph by Howard Hopkins, courtesy of Dewey F. Bartlett Jr.)

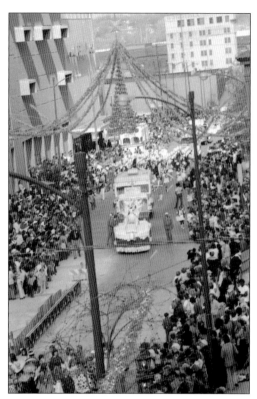

In 1973, downtown Tulsa did not have Christmas lights due to the Federal Energy Administration conservation effort. The lights and decorations returned in 1974, and a decoration light-up ceremony was held the night before the parade at East Fourth and South Main Streets, the intersection seen at left as Santa passes beneath the canopy of tinsel and lights the day of the parade. Below, new light decorations lined the 1987 parade route after old ones were destroyed in a hailstorm the year before. (Left, photograph by J.R. Jones; both, courtesy of *Tulsa World*.)

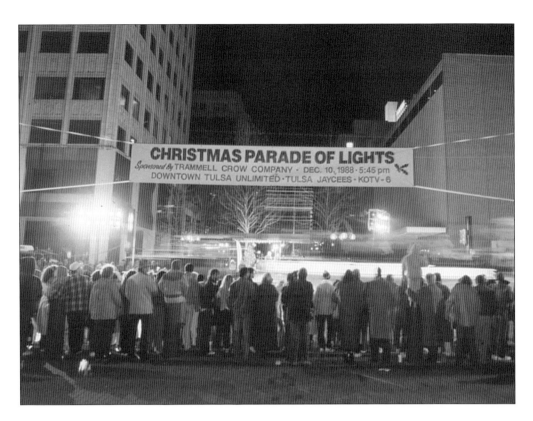

In 1986, the Public Service Company of Oklahoma became the presenting sponsor of the parade, and it was moved to nighttime with a new name: the Parade of Lights. Above, the crowds gather under the sign for the newly renamed parade at the Main Mall on East Third Street at the 1988 parade. Below, the shadow of Ron Henderson is seen painting the 20-by-25-foot logo on South Cincinnati Avenue in front of the Public Service Company of Oklahoma building in preparation for the 2004 parade. (Above, courtesy of Downtown Tulsa Unlimited; below, photograph by Stephen Holman, courtesy of *Tulsa World*.)

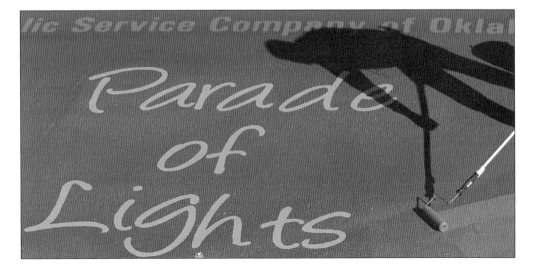

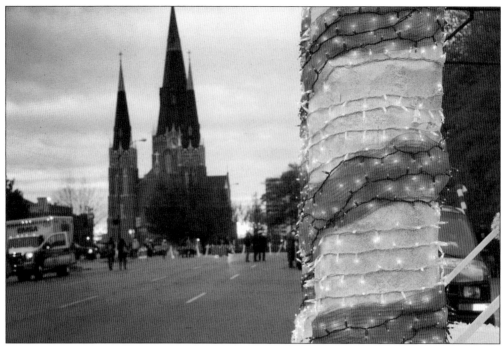

Today, the decorations for the parade are provided by the thousands of lights shining from the floats entered by local church, community, and business groups. Above, a giant illuminated candy cane from the float entered by Real Church in the 2016 parade is highlighted by the beauty of the Cathedral of the Holy Family (in the background), one of Tulsa's many magnificent churches constructed in the 1920s. Below, lights with the parade and sponsor's logos, along with snowflakes and messages of "Merry Christmas," are projected onto buildings at the corner of East Sixth Street and South Boston Avenue as the 2016 parade commences. (Both, photograph by Stephanie Phillips, courtesy of Tulsa Christmas Parade.)

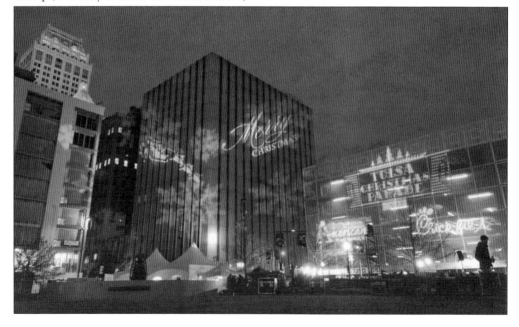

Three

ART DECO THE HALLS

Tulsa has hundreds of architectural masterpieces of varying styles, many of which are in the National Register of Historic Places. The heart of downtown Tulsa was constructed during the height of Art Deco architectural popularity in the 1920s and 1930s, and over the years, these beautiful buildings have provided a breathtaking backdrop for the parade. Here, at the 1954 parade, nine-month-old Debra Ann Boyd gets a photograph with Santa in front of the Mid-Continent Tower on South Boston Avenue, with glimpses of the Atlas Life Building and Philtower Building in the background. (Photograph by Howard Hopkins, courtesy of Dewey F. Bartlett Jr.)

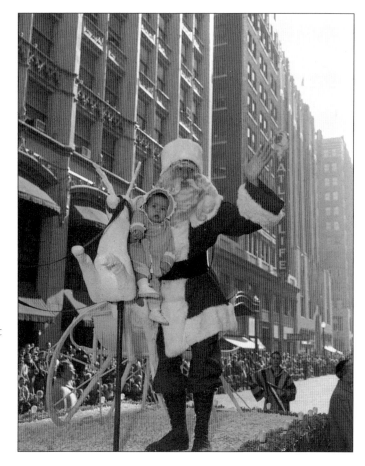

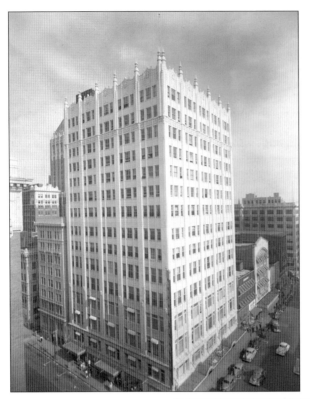

In 1921 a four-story retail establishment named Hunt Dry Goods Co. was opened in downtown Tulsa. In 1924, John A. Brown and John Dunkin joined forces, bought the store, added 11 additional stories, and renamed it Brown-Dunkin Dry Goods Co. In the late 1940s, a new building, seen at left, was unveiled with a bright neon sign on the corner of South Main and East Fourth Streets, seen after dark below. The new building was decorated with trees, lights, and a nativity scene each Christmas season. The building was demolished in 1970 as part of the expansion the First National Bank of Tulsa. In recent years, stricter building ordinances have gone into effect to protect many of Tulsa's remaining historical structures. (Both, photograph by Howard Hopkins, courtesy of Dewey F. Bartlett Jr.)

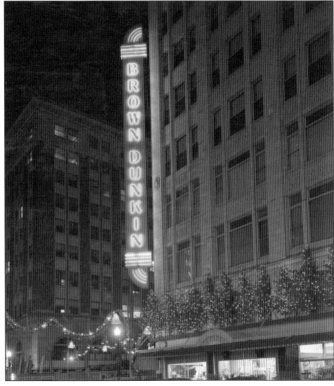

The front of the Brown-Dunkin store is seen here during the 1952 parade; the top floors of the building were rented out as office space. The retail store spanned the first six floors and was a favorite of many for shopping in downtown Tulsa. Brown-Dunkin Dry Goods Co. was bought by Dillard's department store in 1959. (Photograph by Howard Hopkins, courtesy of Dewey F. Bartlett Jr.)

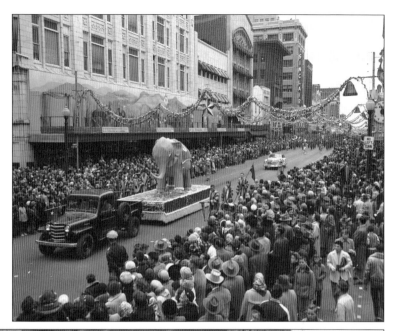

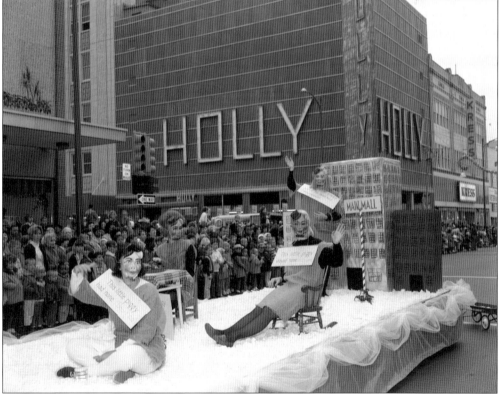

Before the 1970s and 1980s, when most retail in Tulsa moved out of the downtown area, downtown streets were lined with department stores. Two very popular clothing stores on South Main Street in downtown were Holly and Kress, seen here behind a float at the 1965 parade. (Photograph by Howard Hopkins, courtesy of Dewey F. Bartlett Jr.)

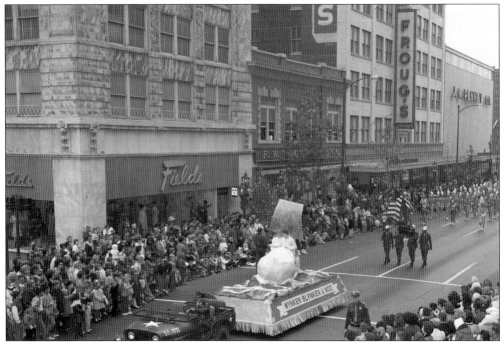

Froug's, founded in 1929 by M.E. Froug and Ohren Smulian, was a department store based in Tulsa, Oklahoma. Its original location was at 316 South Main Street, and by the 1970s, Froug's had 10 stores in the Tulsa area. Froug's father had owned several mercantile stores in small town's surrounding Tulsa and moved his family to Tulsa during the town's first building boom after the Red Fork oil discovery in 1905, so the younger Froug saw Tulsa in its earliest days and remembered a time when Main Street was "hip deep mud." In 1954, Froug served as director of the Tulsa Retail Merchants Association, the group responsible for putting on the Tulsa Christmas Parade. Froug's was sold in 1980, and by 1985, all locations were closed. (Photograph by Howard Hopkins, courtesy of Dewey F. Bartlett Jr.)

At 123 South Boston Avenue, the Bliss Hotel, opened in 1929, was one of the many hotels in downtown Tulsa built in the city's early years. Seen here behind Santa's float at the 1949 parade, with the iconic sign on the corner of South Boston Avenue and East Second Street, it was demolished in 1973. (Photograph by Howard Hopkins, courtesy of Dewey F. Bartlett Jr.)

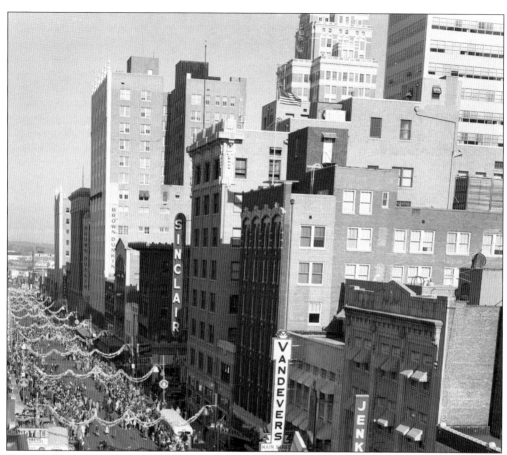

The Oil Capital Building at 507 South Main Street was constructed in 1915. The building was once home to the Ketchum Hotel during the 1920s and 1930s and, for a time, claimed to be the only air-conditioned hotel in Tulsa. The Sinclair Building, just north of the Oil Capital Building at 6 East Fifth Street, was constructed just two years later, in 1917, and the two have been neighbors in downtown Tulsa for 100 years. Sinclair Oil Corporation was the first resident of the structure and occupied the building, which was named for the owner of the company, Harry Ford Sinclair, until 1953. The Sinclair Building, with its sign on the northwest corner of the building, can be seen above during the 1949 parade, with the Oil Capital Building directly to its right. The photograph at right shows both buildings in 1954 after the Sinclair sign was removed. (Both, photograph by Howard Hopkins, courtesy of Dewey F. Bartlett Jr.)

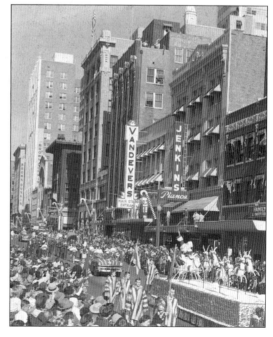

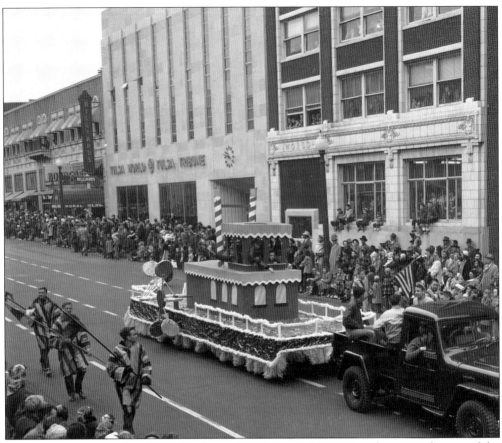

Tulsa World has covered the Tulsa Christmas Parade since the 1920s and sponsored many of the early parades. The Tulsa World Building, at 315 South Boulder Avenue, sits on the current parade route and was at one time also shared with the *Tulsa Tribune*, an afternoon newspaper in Tulsa from 1919 to 1992 that promoted extensively for the first parade in 1926. The building can be seen here during the 1952 parade as a float passes in front of it. (Photograph by Howard Hopkins, courtesy of Dewey F. Bartlett Jr.)

At the 1938 parade, nearly 100,000 people lined the streets, and vehicles were parked anywhere drivers could find a spot at the corner of West Fourth Street and South Boulder Avenue. On the right is the Ritz Theater building, one of several elaborate theaters in downtown Tulsa, with the Goldberg Jewelry sign, and across the street is the Skelly Building, constructed by oil tycoon William G. Skelly. It was one of the many buildings in downtown Tulsa constructed in the 1920s and later demolished during the 1970s and 1980s. (Photograph by Ola Mae Lanton, courtesy of Tulsa Historical Society & Museum.)

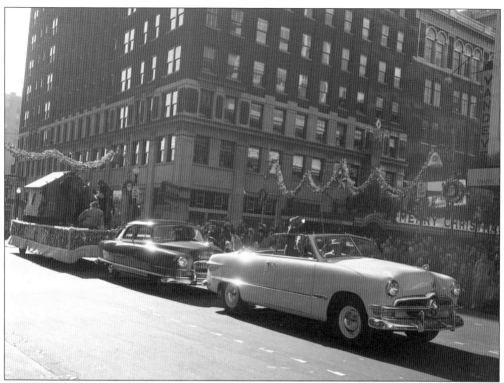

The Thompson Building, at 20 East Fifth Street, was originally constructed as a 10-story structure by brothers William, Jay, and Rob Thompson in 1924. Soon, more office space was needed in the quickly growing oil district in downtown Tulsa, and in 1929, five additional stories were added and topped with an octagonal domed steeple, which contained a regal penthouse. The original building was covered with white stone, which was kept with the 1929 addition and today marks the height of that original structure. The Thompson Building is seen above during the 1949 parade, and again below as a backdrop for one of the 12 marching bands at the 1956 parade. (Both, photograph by Howard Hopkins, courtesy of Dewey F. Bartlett Jr.)

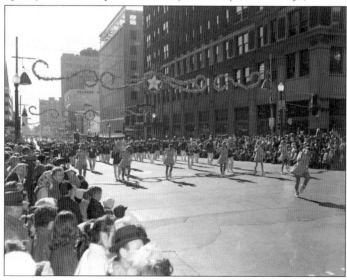

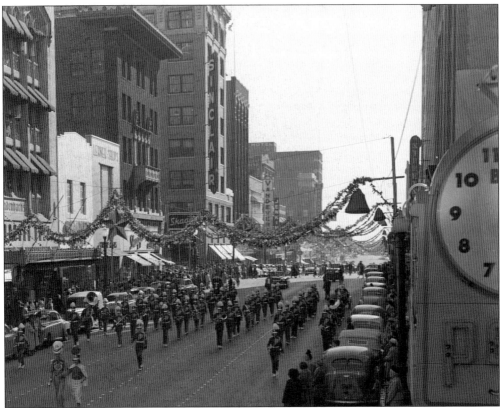

The McFarlin Building, at 5 East Fifth Street, was constructed in 1918 in the Florentine style and named for oil industry pioneer Robert M. McFarlin. It maintains its original red brick on the upper stories of the building to the present day. Seen at the 1951 parade above, in a view facing south, it is the second tall building from the left. Below, in a view facing east, the lower portion can be seen, when Skaggs Drug Center was a tenant on the bottom floor. The McFarlin Building was listed in the National Register of Historic Places in 1979, helping to protect its detailed ornamentation of stone balconies, stylized lions, and urns from being torn down. (Both, photograph by Howard Hopkins, courtesy of Dewey F. Bartlett Jr.)

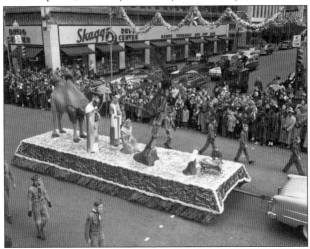

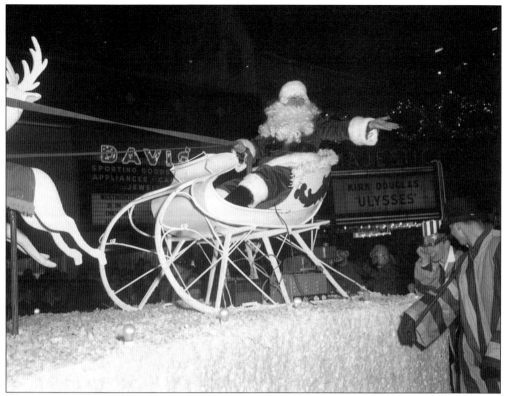

Above, Santa waves to the crowd from his sleigh in front of the Majestic Theater during the 1955 parade; below, crowds gather under its marquee, advertising the movie *Naked Alibi*, at the 1954 parade. Built in 1917 and located at 406 South Main Street, the Majestic showed silent films in the 1920s and conquered many firsts for theaters in Tulsa—the first theater designed for movies, the first with a pipe organ, the first to show a talkie, and the first to show a 3-D movie. At one time, it also boasted the largest electrical sign in Oklahoma. Sadly, the theater was lost to a fire in 1973. (Both, photograph by Howard Hopkins, courtesy of Dewey F. Bartlett Jr.)

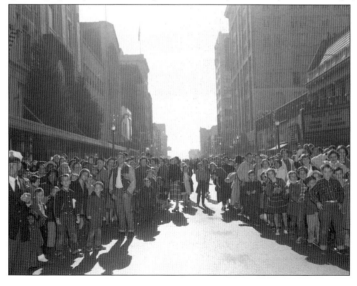

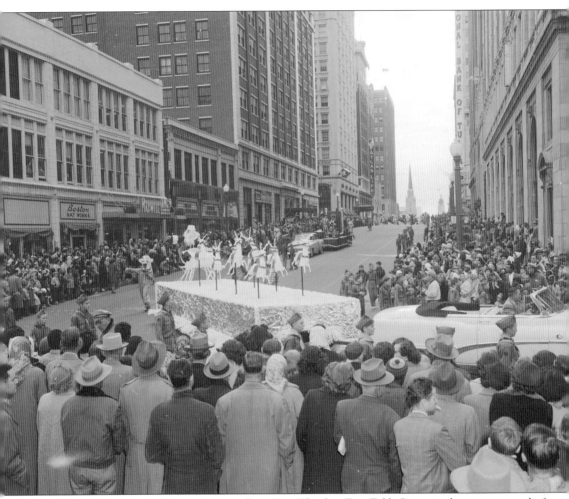

The stretch of South Boston Avenue from East Third to East Fifth Streets is home to several of the most iconic historical buildings in Tulsa. Here, the crowd pushes forward toward Santa in front of the Kennedy Building, left, and the First National Bank of Tulsa, right, during the 1956 parade. At 321 South Boston Avenue, the Kennedy Building, constructed in 1917, was the vision of Dr. Sam Kennedy. The two-story Bagby Building can also be seen nestled between the three-story building at left and the Kennedy Building at right. The Bagby Building was once home to Wheeler Hotel, and its location was originally supposed to the site of an even taller Kennedy Tower, with 24 stories. The tower, however, was never built. Both buildings were sold in 1967; the Bagby Building was demolished shortly after, and the Kennedy Building became home to several large oil companies in the 1970s and 1980s. Today, after extensive renovation to save it in the 1980s, the Kennedy Building is home to office space. (Photograph by Howard Hopkins, courtesy of Dewey F. Bartlett Jr.)

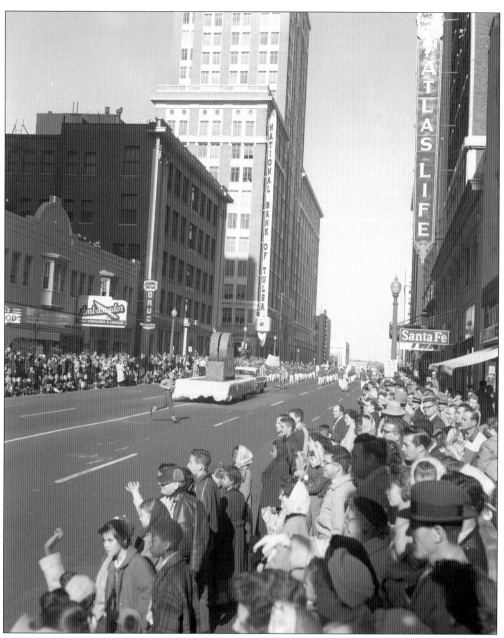

In a view looking north during the 1956 parade, the First National Bank of Tulsa building is seen at left with its unique construction of two 10-story structures flanking a 22-story structure in the middle. The bank's sign, spanning almost the full 10 stories on the corner of East Fourth Street and South Boston Avenue, was 121 feet tall and included a four-face clock, making it the largest sign in the southwestern United States at the time. The First National Bank of Tulsa later became the Bank of Oklahoma and moved to its new location in 1950; the structure is now known as the 320 South Boston Building. With construction starting in 1917 for the 10-story headquarters for the bank, the building eventually extended a full city block and was expanded to its current 22 stories in 1929, making it the tallest building in Oklahoma for two years and the tallest building in Tulsa until 1967. (Photograph by Howard Hopkins, courtesy of Dewey F. Bartlett Jr.)

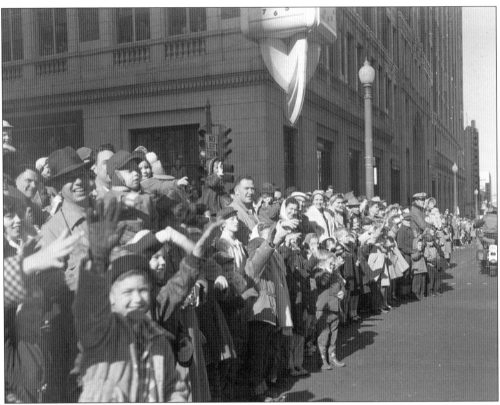

Above, people gather under the clock on the First National Bank of Tulsa sign at the East Fourth Street and South Boston Avenue intersection during the 1956 parade. Seen in the background of this photograph are two of the 55 Tulsa auxiliary policemen that helped to keep the thousands of parade viewers safe that year. The building itself also played an important role in keeping Tulsans safe throughout the years. Its peak, which can be seen at the top of the photograph below from the 1950 parade, was used as a weather alert system, known as the "Weather Teller," during the 1960s and 1970s and was illuminated in different colors to indicate forecast conditions. (Both, photograph by Howard Hopkins, courtesy of Dewey F. Bartlett Jr.)

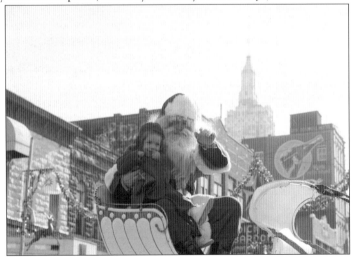

Here, the route is prepared for the 2016 parade as the Mid-Continent Tower (back right), at 401 South Boston Avenue, towers over the street below. Originally known as the Cosden Building and constructed in 1918 as a 16-story tower by one of Tulsa's earliest oil entrepreneurs, Joshua Cosden, it was at the time the tallest reinforced-concrete building west of the Mississippi River. In 1984, an additional 20 stories were cantilevered over the original structure, carefully matching the original architectural detail. Its construction on the corner of East Fourth Street and South Boston Avenue made the skyscraper the first commercial building on a block that was originally reserved for schools and churches in Tulsa's earliest days, leading the way for other commercial structures on South Boston Avenue, such as the Atlas Life Building in 1922 and the Philtower Building in 1928. (Photograph by Stephanie Phillips, courtesy of Tulsa Christmas Parade.)

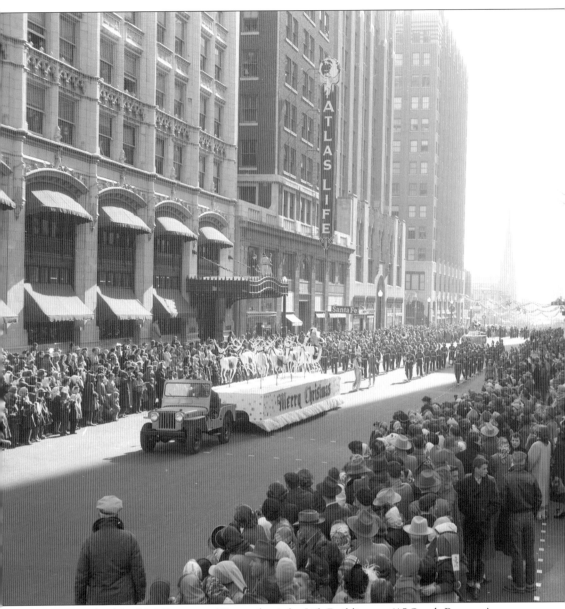

Just south of the Mid-Continent Tower, the Atlas Life Building, at 415 South Boston Avenue, was constructed in 1922 and was added to the National Register of Historic Places on May 19, 2009. Originally constructed as an office building for Atlas Life Insurance Company, it was transformed into a Courtyard by Marriott hotel in 2010. Seen here during the 1949 parade, the iconic Atlas Life sign stretches 55 feet tall and was installed in 1946. The sign almost met its fate when high winds tore it off the building in 1998; after many questions about its status, it was repaired and restored to its retro glory in 2001 and rehung at a relighting ceremony on January 23 that same year. The Philtower Building, at 427 South Boston Avenue, to right of the Atlas Life Building in this photograph, was constructed by oilman Waite Phillips, whose name lives on in several other structures in Tulsa, including the Philcade Building and Philbrook Museum of Art. The Philtower Building has a total of 24 floors; the top eight were transformed into loft apartments in 2004. (Photograph by Howard Hopkins, courtesy of Dewey F. Bartlett Jr.)

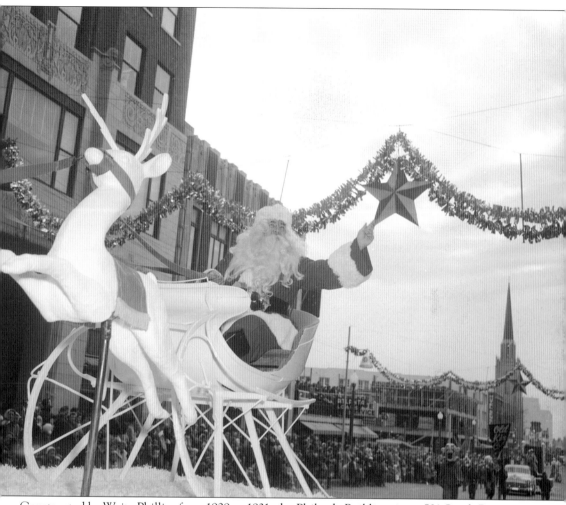

Constructed by Waite Phillips from 1929 to 1931, the Philcade Building sits at 501 South Boston Avenue. The exterior of its ground floor, which is covered in terra-cotta designs including flora, fauna, and Egyptian motifs, can be seen behind Santa during the 1953 parade. It has been home to the Tulsa Art Deco Museum since 2012. The Philcade Building was the first of several structures in Tulsa to have a tunnel constructed underground connecting it to another building; this first tunnel crossed under East Fifth Street and was a passageway for Phillips to travel between his home and his office at the Philtower Building, directly north across East Fifth Street from the Philcade Building. This view, facing south, also shows the steeple of the First Presbyterian Church in the background. Two of Tulsa's founders, brothers James M. and Harry C. Hall, started the original church in their general store in 1882, and the church moved to its current location at South Seventh Street and East Boston Avenue in 1910. The steeple seen here is from its building constructed in 1926, the same year as the first Christmas parade. (Photograph by Howard Hopkins, courtesy of Dewey F. Bartlett Jr.)

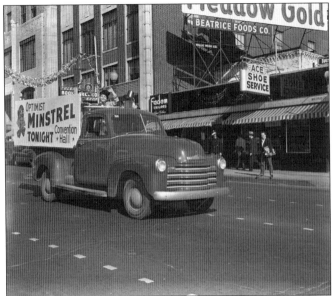

Another view of the south end of the Philcade Building is seen at left. On the right is a Meadow Gold sign at the corner of East Sixth Street and South Boston Avenue. A larger version of the Meadow Gold sign that sits on the stretch of Route 66 that passes through Tulsa has been an iconic piece of Tulsa history since it was first erected in the 1930s. It was later preserved and moved in 2009 to 1324 East Eleventh Street, a few blocks west of its original location. (Photograph by Howard Hopkins, courtesy of Dewey F. Bartlett Jr.)

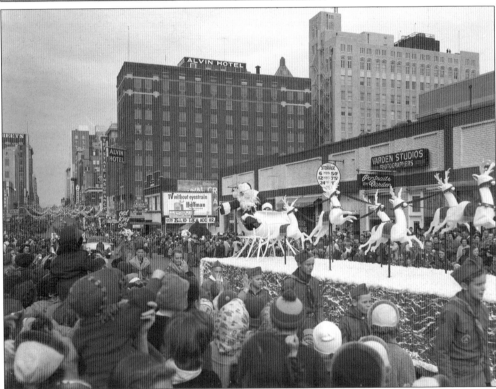

Built in 1928, the Alvin Hotel, seen here during the 1953 parade, stood on the northeast corner of South Seventh and East Main Streets in downtown Tulsa. The hotel served Tulsa during a time when many new hotels were being built to support the growth of the oil industry. The Barbershop Harmony Society, today an organization with an international membership, was started in the Alvin Hotel in 1938 by Rupert Hall and Owen Clifton Cash and continued to meet there for 37 years. (Photograph by Howard Hopkins, courtesy of Dewey F. Bartlett Jr.)

The Halliburton-Abbott Building, also known as the Sears Building as well as the Skaggs Building throughout its history, displays the Skaggs Drug sign as the intersection of West Fifth Street and South Boulder Avenue. It is decorated and ready for the 1965 parade. While the building, an example of terra-cotta Art Deco architecture, was demolished in the 1980s, several of its ornamental exterior decorations were saved and are now displayed at the Tulsa Art Deco Museum. (Courtesy of *Tulsa World.*)

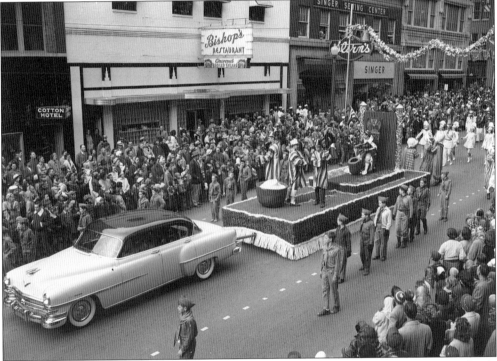

Another fashionable place to be on the downtown streets was in one of the many cafés and soda shops. Opened in 1930 at 510 South Main Street as an upgrade to the original restaurant a few blocks north that was started in 1913 by W.W. Bishop, Bishop's Restaurant was the place to be in downtown Tulsa, and being open 24 hours secured its spot as the hub of downtown activity. Seen here during the 1953 parade, the restaurant was closed in 1966, but some of its more famous recipes can be found online for past patrons to re-create. (Photograph by Howard Hopkins, courtesy of Dewey F. Bartlett Jr.)

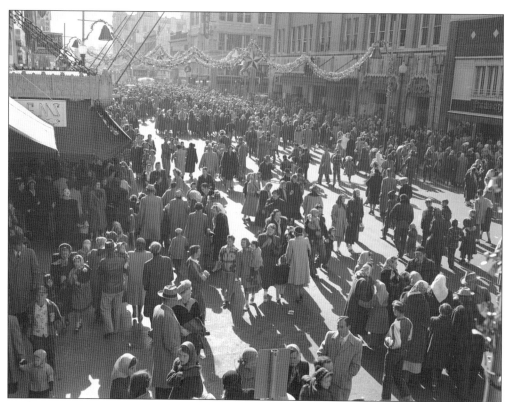

With construction starting in 1909 and continued with expansion several times until completion in 1917, the Mayo Building—pictured at the top of the photograph above during the 1949 parade and behind the 'Twas the Night Before Christmas float at the 1956 parade below—is the oldest oil structure still standing in Tulsa. Brothers Cass and John Mayo, who originally owned a furniture store in Tulsa, saw the need for office space for growing oil companies and started construction on the building at 420 South Main Street. At the time, critics thought the brothers were building too far south, but with the continued boom of oil, the structure was soon at maximum capacity, spawning two expansions to reach its final height of 10 stories, at the time considered a skyscraper on the Tulsa skyline. It was the beginning of a small empire of buildings in Tulsa financed by the Mayo brothers. (Both, photograph by Howard Hopkins, courtesy of Dewey F. Bartlett Jr.)

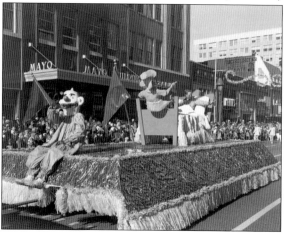

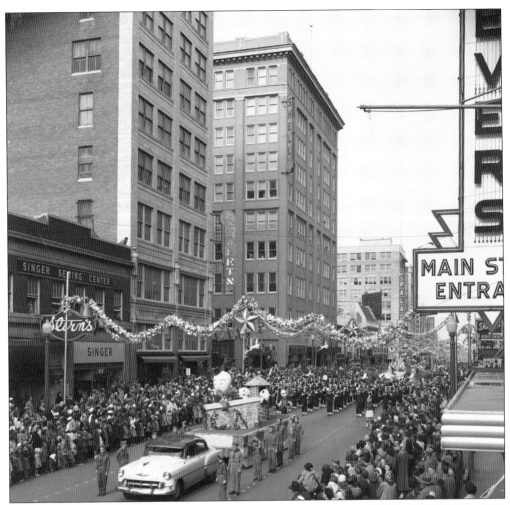

The original building has had many tenants over the years, such as Shell Oil Company, whose sign can be seen in the photograph above during the 1953 parade. Another famous building that bears the Mayo name and owes its origins to the Mayo brothers is the Mayo Hotel, at 115 West Fifth Street. Built in 1925, it was at one time the tallest building in Oklahoma and patterned after the Plaza Building in New York City. The iconic sign on the roof of the 18-floor Mayo Hotel has graced the Tulsa skyline for decades and can be seen in the background of the photograph at right from the 1963 parade. (Both, photograph by Howard Hopkins, courtesy of Dewey F. Bartlett Jr.)

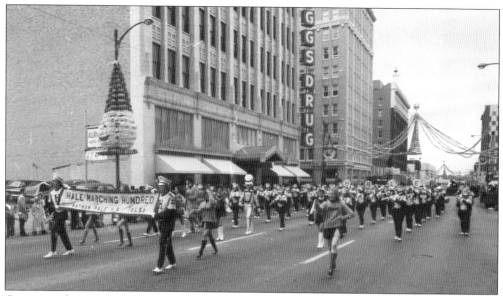

Constructed in 1923, the Beacon Building, at 406 South Boulder Avenue, was famous for the iconic beacon light tower on its roof. The top of the light tower can be seen in the photograph above from the 1973 parade as the Hale Marching Hundred from Nathan Hale High School march down South Boulder Avenue. Three years after this photograph, the light tower was removed due to a pigeon infestation. The beautiful detail of the limestone arches on the lower facade and iron awning can be seen in the photograph below during the 1979 parade. (Above, courtesy of *Tulsa World*; below, courtesy of Downtown Tulsa Unlimited.)

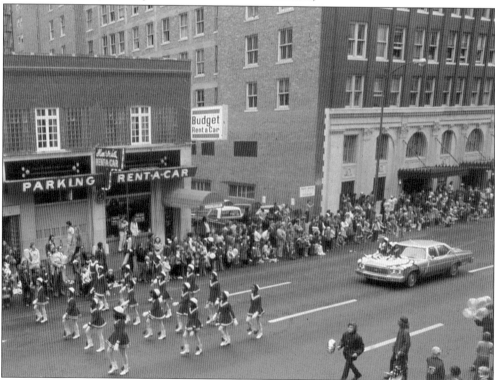

Seen at right during the 1953 parade, the Public Service of Oklahoma Building, at 604 South Main Street, was constructed in 1929 and considered a predecessor in ushering in the Art Deco style to downtown Tulsa structures. This popularity led the way to Tulsa having more buildings 10 stories or taller than any other city of its size in the world in 1930. Its beautiful limestone and sconces, which illuminate the exterior of the building at night and earned it the moniker "monument of lights" when it was built, can be seen below behind a float in the 1979 parade. Now known as the TransOK Building, in 2016 it was converted to Art Deco Lofts and Apartments. (Right, photograph by Howard Hopkins, courtesy of Dewey F. Bartlett Jr.; below, courtesy of Downtown Tulsa Unlimited.)

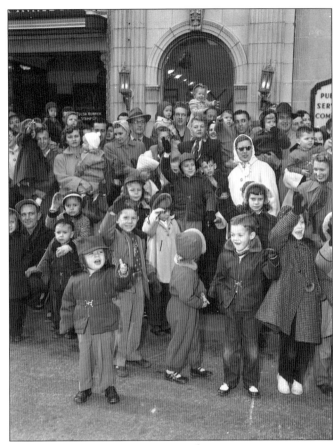

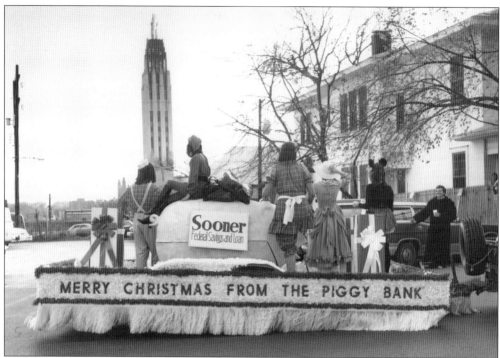

Downtown Tulsa is known for the architectural beauty of many of the city's earliest churches. Above, the Sooner Federal Savings and Loan float is waiting for the parade to start during the 1950s. Seen in the background is the tower of the Boston Avenue United Methodist Church, at 1301 South Boston Avenue. Originally built from 1924 to 1929, placed in the National Register of Historic Places in 1978, and designated a National Historic Landmark in 1999, the church is a rare example of Art Deco architecture in churches, as well as one of the only churches with a skyscraper, in the United States. Below at the 2016 parade, the tower can be seen at right, in a view looking south on South Boston Avenue from East Seventh Street, while the steeples of the First Presbyterian Church, the first permanent Protestant church in Tulsa, are in the foreground at left. Started in 1885 by one of Tulsa's founders, James Hall, the First Presbyterian Church constructed a building at 709 South Boston Avenue in 1926. (Above, courtesy of Tulsa Historical Society & Museum; below, photograph by Stephanie Phillips, courtesy of Tulsa Christmas Parade.)

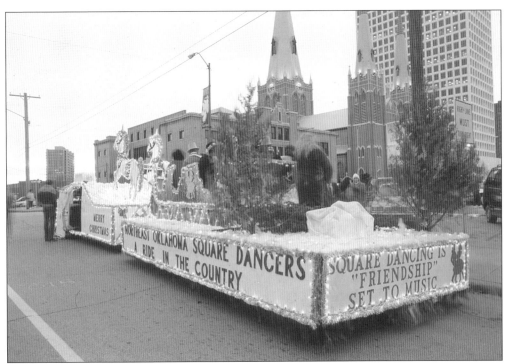

Above, the Holy Family Cathedral, at 122 West Eighth Street, can be seen in the background behind the Northeast Oklahoma Square Dancers float from 1988. Constructed from 1912 to 1919 and added to the National Register of Historic Places in 1982, it was the tallest building in Tulsa until it was surpassed by the Mayo Hotel in 1923. Below, in the background of the 1979 parade, glimpses of two more of Tulsa's beautiful, historic downtown churches can be seen: the dome of the First Christian Church, at 913 South Boulder Avenue, and the steeples of the First United Methodist Church, at 1115 South Boulder Avenue, built in 1920 and 1921, respectively. (Both, courtesy of Downtown Tulsa Unlimited.)

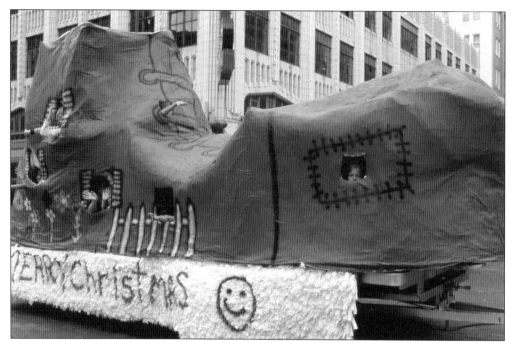

Behind a float of the Old Woman Who Lived in a Shoe in the 1979 parade, a small glimpse of the regal exterior of the Pythian Building can be seen. It was originally slated as a 13-story showcase by two of Tulsa's early oilmen, J.M. Gillette and H.C. Tyrell. In 1929, construction was halted with the onset of the Great Depression, and the three stories completed in 1931 continue to impress downtown visitors to this day. Another view of the building can be seen behind Tulsa's KTUL Channel 8 car. KTUL is the current media sponsor of the parade and broadcasts live coverage of it each year. (Both, courtesy of Downtown Tulsa Unlimited.)

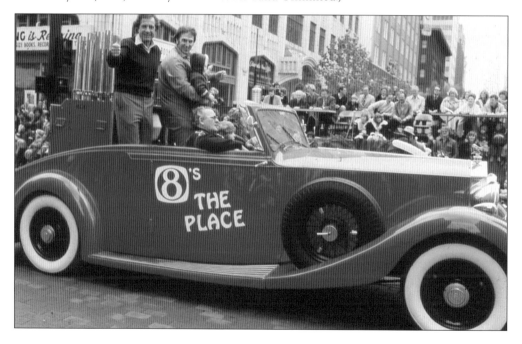

Four

DO YOU HEAR
WHAT I HEAR?

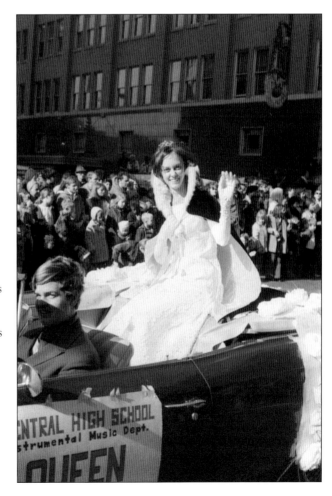

College, high school, and community bands and drill teams have been crowd-pleasers since the first Christmas parade in 1926 when the Tribune Newsboys band from a local newspaper, the *Tulsa Tribune*, played "Jingle Bells" to escort Santa through downtown Tulsa. Here, a beauty queen from Central High School's Instrumental Music Department leads her school's marching band, one of 27 school bands at the 1970 parade. (Courtesy of *Tulsa World*.)

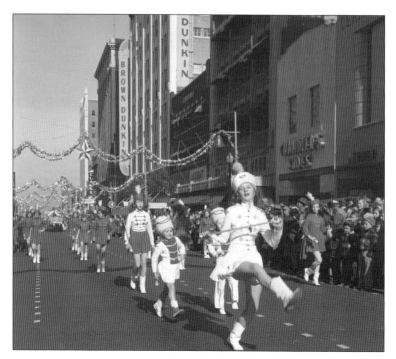

Marching musicians and dancing drill teams are beloved by the thousands lining the streets each year to watch the parade, and many years, bands make up a large portion of the lineup with their festive fusions. Seen here is a troupe of 35 baton twirlers from Sapulpa High School at the 1949 parade. (Photograph by Howard Hopkins, courtesy of Dewey F. Bartlett Jr.)

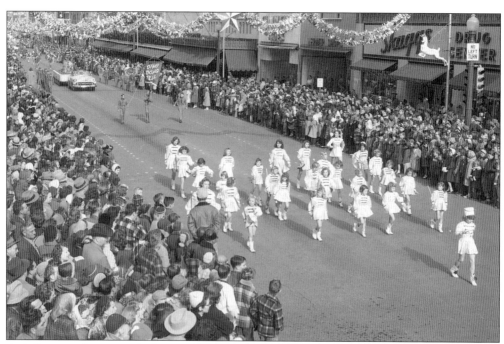

A drill team of young girls dances down South Main Street leading the Ding Dong Bell float under a canopy of shiny garland at the parade on November 22, 1952. (Photograph by Howard Hopkins, courtesy of Dewey F. Bartlett Jr.)

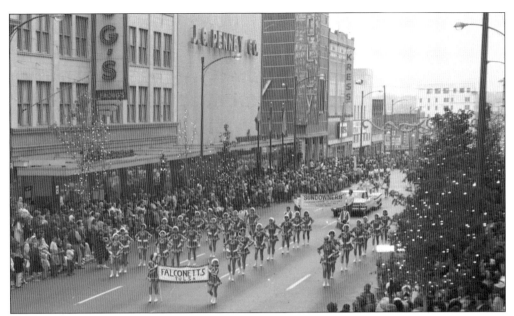

The Falconettes, a drill team from Alexander Hamilton Junior High in Tulsa, march at the parade on November 22, 1965. (Photograph by Howard Hopkins, courtesy of Dewey F. Bartlett Jr.)

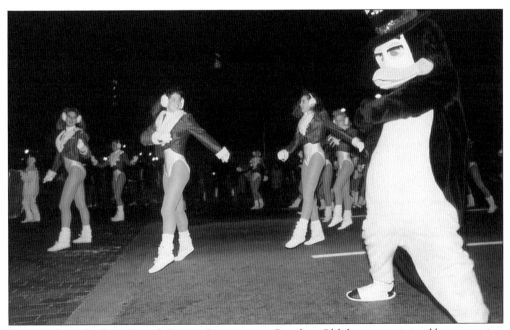

Dancers from the Patti Parrish Dance Company, in Sapulpa, Oklahoma, are joined by a prancing penguin at the Christmas Parade of Lights on December 10, 1988. (Courtesy of Downtown Tulsa Unlimited.)

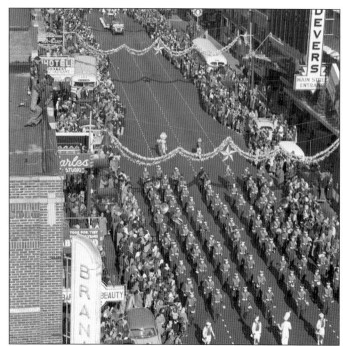

A group of young boys tries to get the best view of the parade on the roof of the Braniff Building, at West Sixth and South Main Streets, on November 25, 1949. Shown below them is one of the 15 bands parade marching down South Main Street that year. Combined, the bands totaled 1,200 musicians and included local bands from the Tulsa Musicians Protective Association and Tulsa schools, such as Central High School, Webster High School, Booker T. Washington High School, and Union High School. (Photograph by Howard Hopkins, courtesy of Dewey F. Bartlett Jr.)

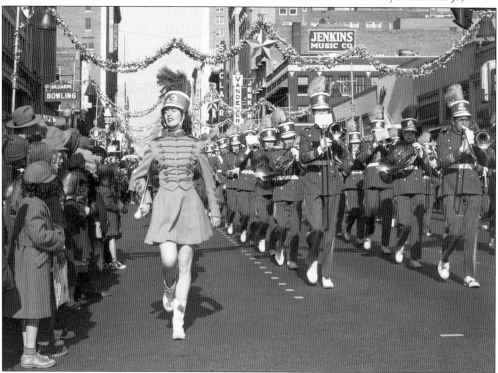

One of 10 bands from outside of Tulsa, the Pride of Pryor Band, from Pryor Creek, Oklahoma, steps in sync to a song at the 1949 Christmas parade. Formed in the late 1800s around the railroad that passed through the town, Pryor Creek is a small town northwest of Tulsa, Oklahoma. (Photograph by Howard Hopkins, courtesy of Dewey F. Bartlett Jr.)

All the way from Collinsville, Oklahoma, a small town north of Tulsa, the Collinsville Crimson Cadets captivate the crowds gathered along South Main Street at the Christmas parade on November 25, 1949. That year, the parade took 10 twists and turns in all directions, starting at the Tulsa Convention Hall and North Boulder Avenue and West Brady Street and ending at the Magic Empire Building on South Boulder Avenue. (Photograph by Howard Hopkins, courtesy of Dewey F. Bartlett Jr.)

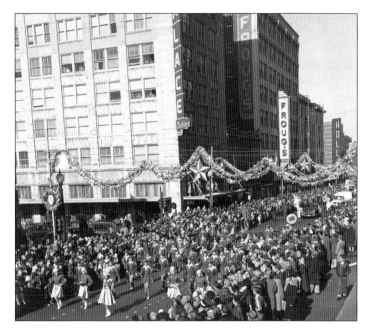

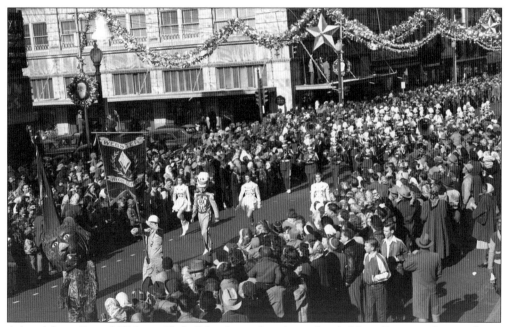

A band from Daniel Webster High School marches down South Main Street at the parade on November 25, 1950. One of the original public high schools in Tulsa, Daniel Webster High School has served grades 9–12 in west Tulsa since 1938 and is one of the few public schools to still occupy its original building, known for its Art Deco architecture and deemed a "hidden gem" by some. (Photograph by Howard Hopkins, courtesy of Dewey F. Bartlett Jr.)

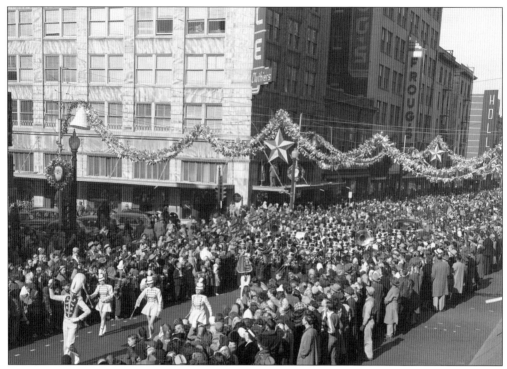

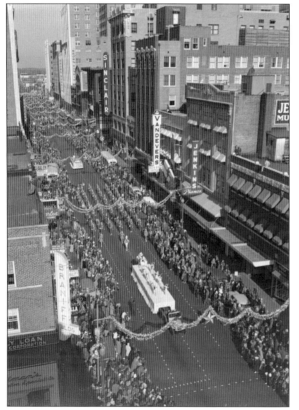

The crowds pushed in so close at the 1949 parade, the band seen above could barely pass down the street. Ten bands from out of town traveled to Tulsa to participate in the 1949 parade: Nowata, Pryor, Bristow, Claremore, Okmulgee, Sapulpa, Collinsville, Owasso, Sand Springs, and Bixby. (Photograph by Howard Hopkins, courtesy of Dewey F. Bartlett Jr.)

A marching band follows Santa's float south down South Main Street. Starting at the Tulsa Convention Hall, at North Boulder Avenue and West Brady Street, and after several detours through the streets of downtown, the parade ended at the Magic Empire Building on South Boulder Avenue, where a special luncheon, hosted by local newspapers *Tulsa World* and the *Tulsa Tribune*, was held for the more than 1,000 musicians from the 13 bands in the 1950 parade. (Photograph by Howard Hopkins, courtesy of Dewey F. Bartlett Jr.)

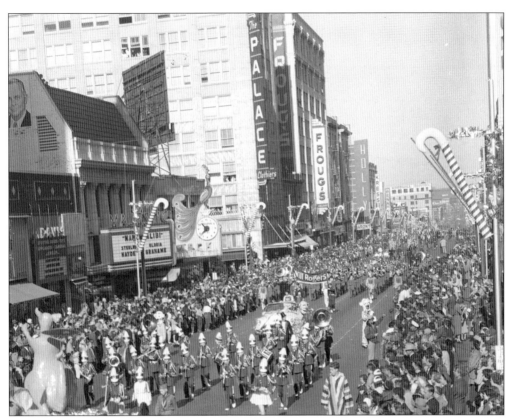

Throughout most of the 1940s and 1950s, an average of a dozen bands participated in the parade each year. But in 1954, parade attendees were treated to a special treat when over 30 bands from around the state of Oklahoma, including Will Rogers High School (above) and Central High School (below), both from Tulsa and seen here marching down South Main Street, performed at the parade in conjunction with Band Day being held at the University of Tulsa for the University of Tulsa versus University of Wyoming football game after the parade. Tulsa City Lines donated bus services to transport the musicians from the school to downtown and then back again. (Both, photograph by Howard Hopkins, courtesy of Dewey F. Bartlett Jr.)

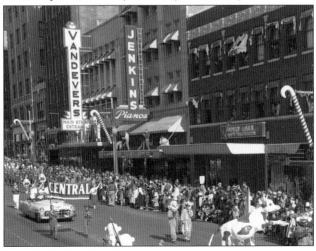

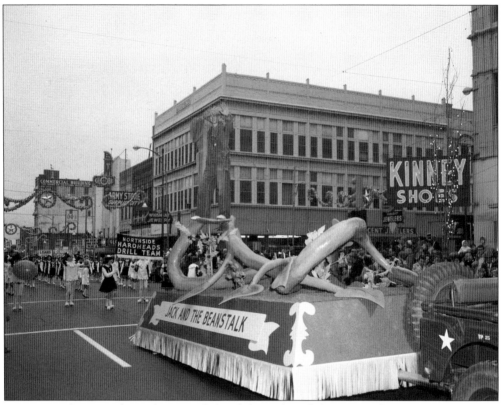

Drumming their way down the street behind the Jack and the Beanstalk float, the Northside Hard Heads Drill Team from McClain High School entertains the eager crowds at the parade on November 22, 1965. McLain High School is the northernmost high school in Tulsa and has served the city since 1959. (Photograph by Howard Hopkins, courtesy of Dewey F. Bartlett Jr.)

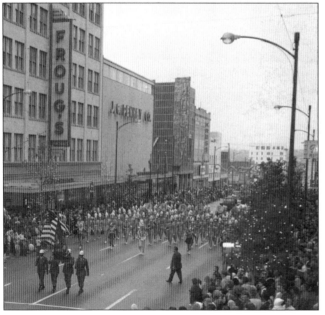

The Nathan Hale High School Hale Marching Hundred are seen here entertaining parade goers as the band marches past Froug's Department Store on South Main Street during the 1965 parade. First opened in 1959, Nathan Hale High School serves grades 9–12 in south Tulsa. (Photograph by Howard Hopkins, courtesy of Dewey F. Bartlett Jr.)

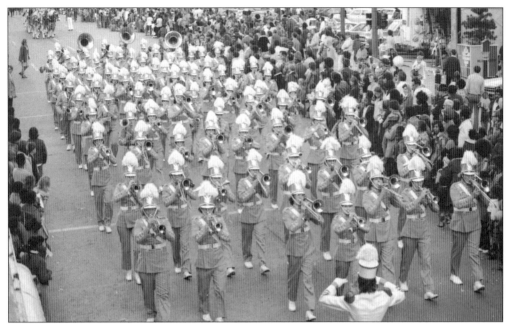

In the 1950s and 1960s, bands were very popular at the parade and their number seemed to grow each year. An average of a dozen bands played at the parade throughout the 1950s. By the 1974 parade (seen here), every high school and junior high band in Tulsa, including many from outside Tulsa, were in the parade, with a total number of 24 bands tooting, drumming, and marching down the 2.5-mile route. (Courtesy *Tulsa World*.)

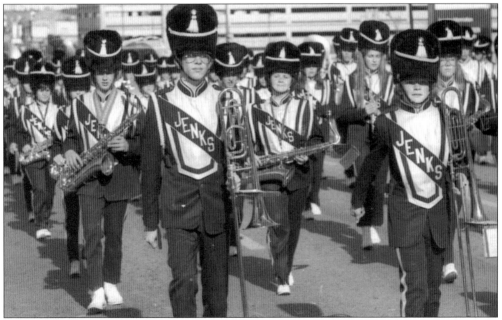

Seen here is the Jenks High School Marching Band as it marches in the 1975 parade. Jenks Public Schools, in Jenks, Oklahoma, a suburb southwest of Tulsa, dates back to 1908. The Jenks marching band has participated in many parades throughout the history of the Tulsa Christmas Parade. (Courtesy of *Tulsa World*.)

Established in 1908, Booker T. Washington High School was originally located in Tulsa's Greenwood District and served all grades until 1913. The school is well known for its marching band, the Hornets, seen here at the Christmas Parade of Lights on December 10, 1988. (Courtesy of Downtown Tulsa Unlimited.)

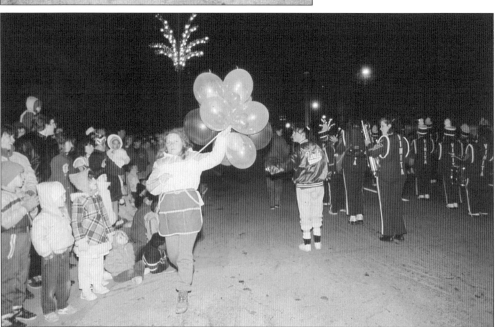

The Vinita High School Blue Pride Band performs during the parade on December 10, 1988. Vinita, Oklahoma, northeast of Tulsa, is home to the first bridge restaurant in the world, a McDonald's built in 1957. It was, at one time, considered the largest McDonald's in the world. (Courtesy of Downtown Tulsa Unlimited.)

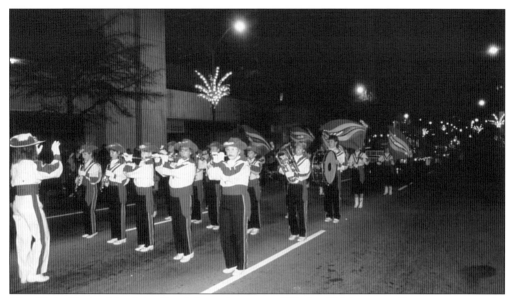

The Kiefer Trojan Marching Band, from the town of Kiefer, Oklahoma, strikes up a song at the December 10, 1988, Christmas Parade of Lights. Kiefer, southwest of Tulsa, was established in 1901 and became a boomtown during the oil days of the early 20th century. The town served as a shipping location for oil from the oil field in Glenpool, Oklahoma. (Courtesy of Downtown Tulsa Unlimited.)

Ashley Mays (front and center) and other festively dressed dancers step in perfect form as they enthusiastically lead the way for Central High School's marching band. Their warm smiles betray the chilly temperatures as they brave the night air and entertain the crowds at the December 13, 2003, parade. Founded in 1906, Central High School is the oldest high school in Tulsa and was originally located at East Fourth Street and South Boston Avenue, an intersection known as the hub of the "Oil Capital of the World" in the 1920s. Now located in west Tulsa, Central High School is known as a performing arts magnet school and has participated in the Christmas parade since its earliest days. (Courtesy of *Tulsa World*.)

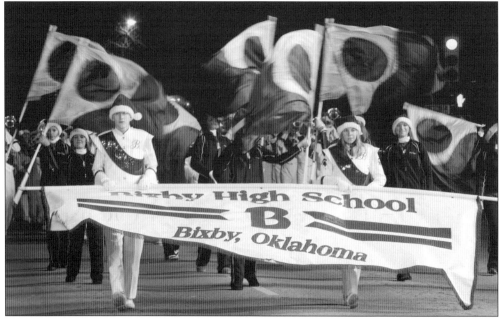

The Bixby High School Marching Band, from Bixby, Oklahoma, a suburb southeast of Tulsa, is led by students carrying a banner and twirling flags as it marches down South Cincinnati Avenue at the PSO Christmas Parade of Lights on December 13, 2008. (Photograph by James Gibbard, courtesy of *Tulsa World*.)

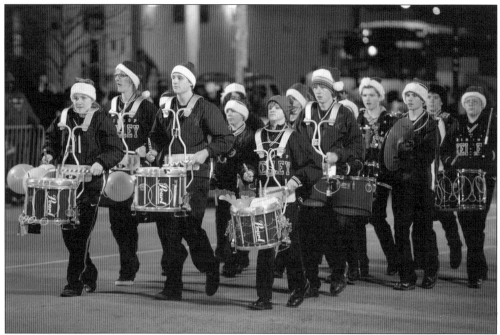

With Santa hats that match their drums and other merry decorations, the Bishop Kelly High School Marching Band proceeds down Fourth Street in the Holiday Parade of Lights on December 10, 2011. Bishop Kelly High School, founded in 1960, is a Catholic school in midtown Tulsa. (Photograph by Jeff Lautenberger, courtesy of *Tulsa World*.)

Five

HOLLY JOLLY
FLOATS AND BALLOONS

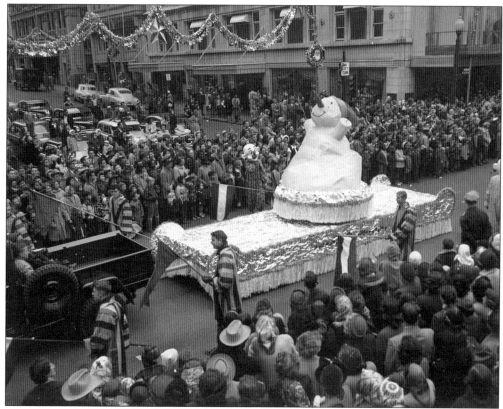

Floats and balloons have always been among the favorite crowd-pleasers in the parade each year. In the 1950s, the committee over the parade at that time, the Tulsa Retail Merchants Association, orchestrated custom-built elaborate floats that were stored, updated, and reused to prolong their lives. Here, a snowman float passes the intersection of West Sixth and South Main Streets during the 1952 parade. (Photograph by Howard Hopkins, courtesy of Dewey F. Bartlett Jr.)

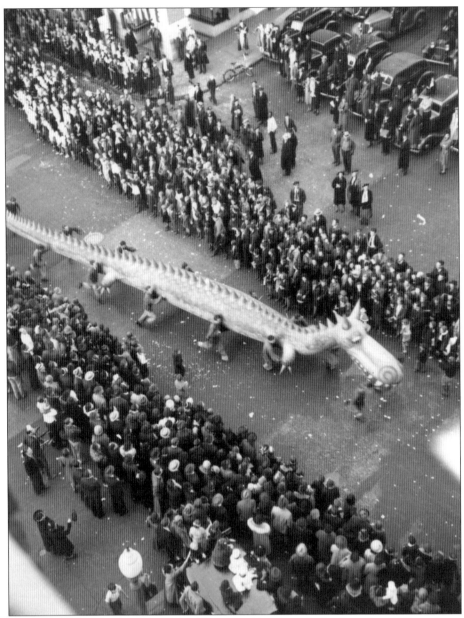

Balloons have been a part of the Tulsa Christmas Parade as far back as the 1930s and are still favorites of the crowds that gather each year at the parade. In 1938, the parade was called *Tulsa World's* Santa Claus and Balloon Parade and was held on Monday afternoon, November 28, at 4:00 p.m. The highlight of the parade was the 30 giant inflatables, designed by Jean Gros, an internationally known designer of French marionettes, and manufactured by the Aeronautics Department of Goodyear Tire and Rubber Company. *Tulsa World* and the Tulsa Retail Merchants Association arranged to have the balloons made especially for the parade, an investment of over $23,000, with balloons ranging in price from $500 to $3,000. The stars of the parade were handmade and took several months to design, manufacture, and then finish with decorations of colorful rubber paint. Here, the 100-foot-long Dracula the Dragon character is carried down the route by people dressed as clowns. (Courtesy of Tulsa Historical Society & Museum.)

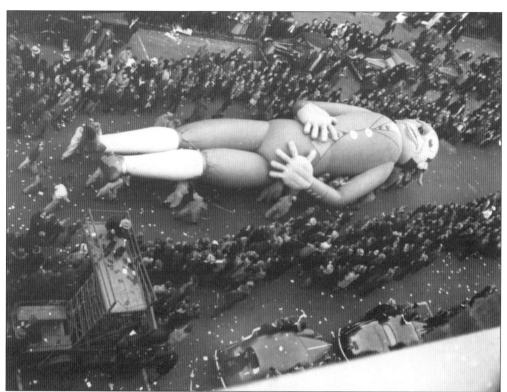

The cast of blown-up figures included four-foot-tall smiling heads, a 14-foot-tall hippopotamus, Donald Duck, Peter Rabbit, and the 50-foot-long giant man seen above. At right, Felix the Cat passes in front of the Skelly Building, at West Fourth Street and South Boulder Avenue. In between the balloons, bands from Tulsa and other surrounding towns marched and played Christmas music. After the parade, the sponsor, *Tulsa World*, hosted a lunch for the parade participants at Michaelis Cafeteria, at 507 South Boulder Avenue, a tradition that would last for several decades in various locales. (Above, photograph by Ola Mae Lanton, courtesy of Tulsa Historical Society & Museum; right, courtesy of Tulsa Historical Society & Museum.)

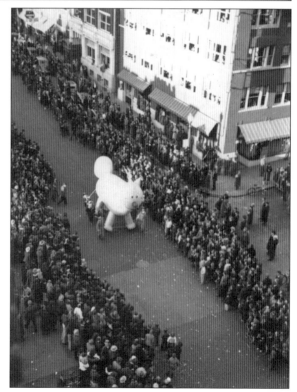

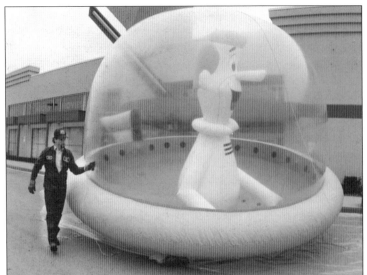

Scott McManus, a Downtown Tulsa Unlimited employee, helps test the George Jetson balloon the day before the 1997 parade. The balloon, sponsored by Sprint PCS and measuring 16 feet tall and nine feet wide, is being tested with cold air. For the parade, it was filled with 4,656 cubic feet of helium and carried by 14 handlers. (Courtesy of *Tulsa World*.)

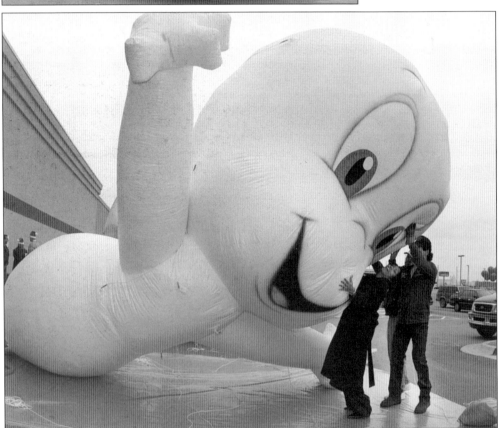

Casper the Ghost reaches out for a hug from Nichol Starks (left), executive director of the John Starks Foundation; Scott McManus (center), a Downtown Tulsa Unlimited employee; and an unidentified man as he is tested the day before the 1997 parade. The night of the parade, Casper was filled with 1,455 cubic feet of helium and guided by eight volunteers as he floated 25 feet above the spectators. (Photograph by Tom Gilbert, courtesy of *Tulsa World*.)

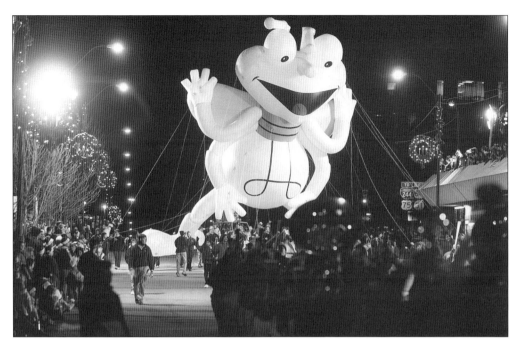

American Electric Power-Public Service Company of Oklahoma's corporate mascot, Louie the Lightning Bug, buzzes his way down South Boston Avenue during the Christmas Parade of Lights on December 14, 2002. (Photograph by Stephen Holman, courtesy of *Tulsa World*.)

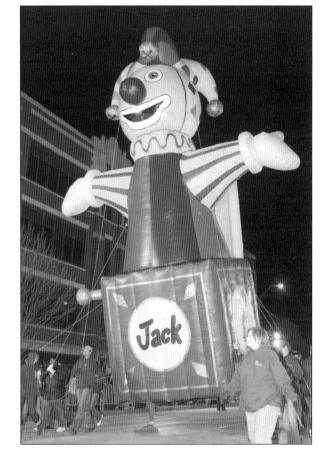

Jack in the Box, a balloon sponsored by Borg Compressed Steel Corporation, a location of the Yaffe Companies, Inc., in Tulsa, floats down the route at the Parade of Lights on December 9, 2006. (Photograph by A. Cuervo, courtesy of *Tulsa World*.)

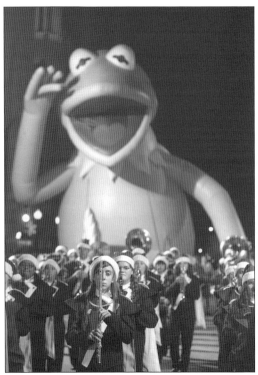

Donning Santa hats along with their uniforms, the members of the Marching Eagles band, who traveled from Paris, Arkansas, to share their music with the excited crowds, led the way for the Kermit the Frog balloon as he waves to the crowd during the 2014 Tulsa Christmas Parade. (Photograph by James Gibbard, courtesy of *Tulsa World*.)

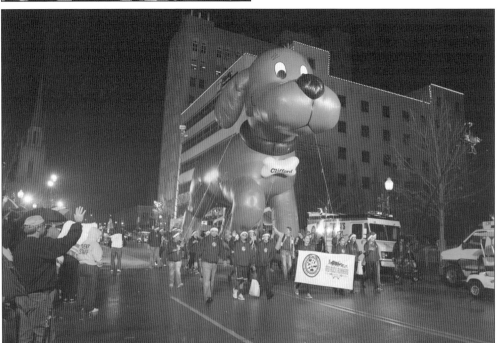

This helium-filled balloon, Clifford the Big Red Dog, was rained on during the 2015 Tulsa Christmas Parade, but that did not dampen the mood of parade and balloon sponsors Red Dog Construction as they carried him down the South Boston Avenue. In the background, one of the spires of Holy Family Cathedral can be seen at left. (Photograph by Brett Rojo, courtesy of *Tulsa World*.)

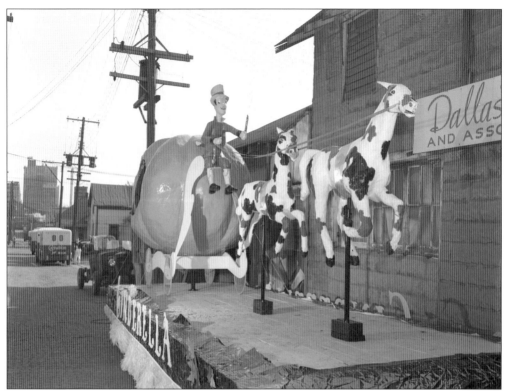

Seen above in the staging area at the 1950 parade, the Cinderella float needed a little help from a fairy godmother after the truck pulling it got a flat tire. Thankfully, several of her helpers were nearby in the form of friendly Good Samaritans, and they changed the tire just in time to make it into the procession. The float is seen below on South Main Street passing by Palace Clothier's, one of the many stores that extended their hours the day of the parade to accommodate the influx of shoppers after the festivities. (Both, photograph by Howard Hopkins, courtesy of Dewey F. Bartlett Jr.)

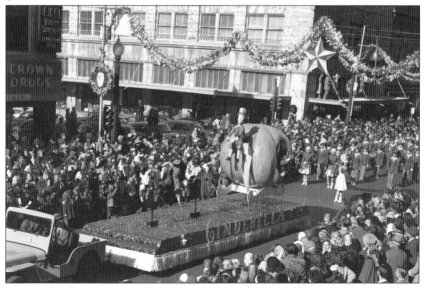

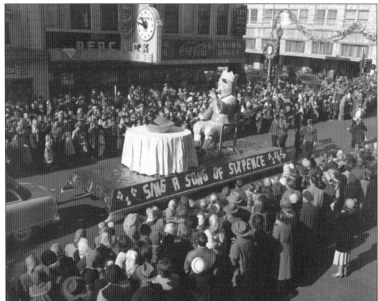

The committee suffered slight embarrassment when *Tulsa World* reported it had misspelled *sixpence* on one side of a float as "sixpense." Thankfully, the other side, facing the cameras, was spelled correctly. (Photograph by Howard Hopkins, courtesy of Dewey F. Bartlett Jr.)

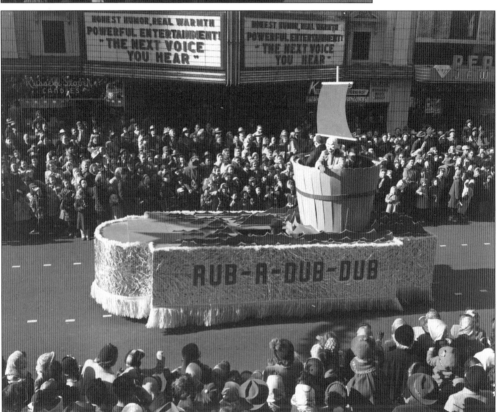

The Rub-A-Dub-Dub float was one of 12 Mother Goose–themed floats at the 1950 parade, seen here on South Main Street under the marquee for the Majestic Theater. The parade also included music from more than 1,000 musicians in 13 bands from local Tulsa schools and many from out of town. (Photograph by Howard Hopkins, courtesy of Dewey F. Bartlett Jr.)

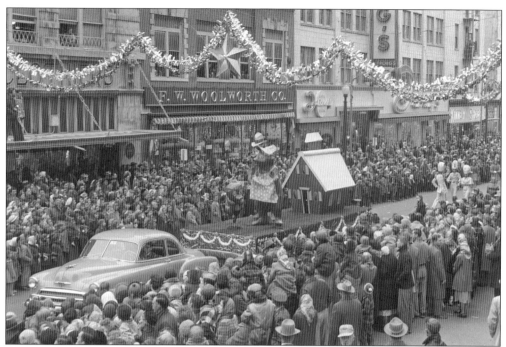

Seen above is the Goldilocks and the Three Bears float with Papa Bear puffing on a cigar as the float makes its way down South Main Street during the 1951 parade. While fairy-tale animals, like the Mama, Papa, and Baby Bear that were handmade by the parade committee, were always extremely popular, real animals stole the show. Below, at the 1954 parade, a float carries a baby elephant named Ghunda from the Mohawk Zoo in Tulsa. She is escorted by the junior chamber of commerce group, the Tulsa Jaycees. (Both, photograph by Howard Hopkins, courtesy of Dewey F. Bartlett Jr.)

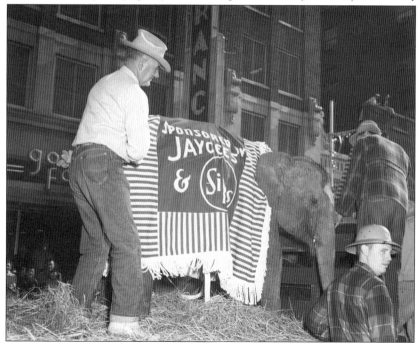

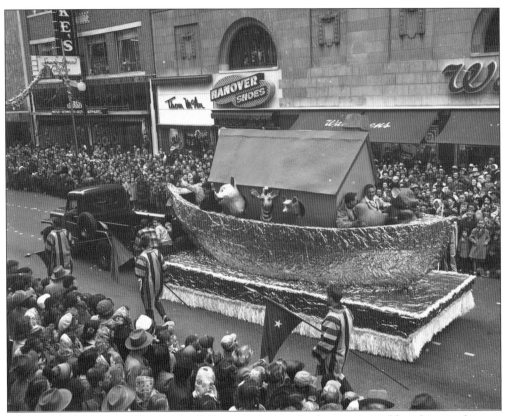

Above is the Noah's Ark float at the 1952 parade, painted a shimmering gold to shine in the sun. The float had a man dressed as Noah and animals, including a giraffe, a calf, baby chickens, a white swan, a bear, and a pig, poking their heads out of the portholes on the side. The Noah's Ark float and the Three Wise Men float, seen below, were both designed by Dallas Meade, who was in charge of the float-building group. (Both, photograph by Howard Hopkins, courtesy of Dewey F. Bartlett Jr.)

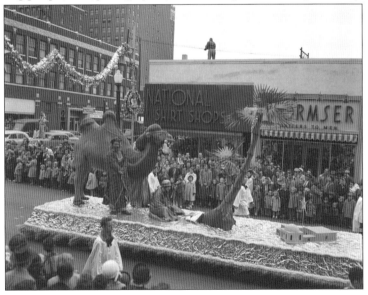

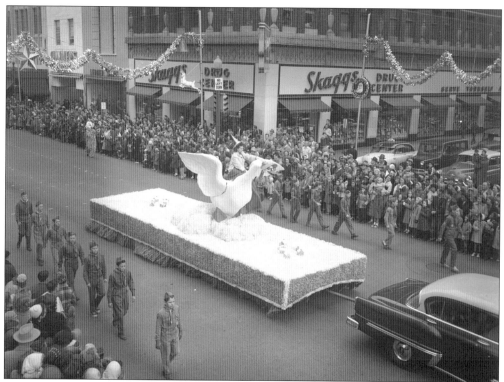

Seen above and below on South Main Street are two of the 12 floats all newly designed around Mother Goose storybook characters for the 1953 parade. The Old Mother Goose float (above) has a young girl dressed up as a fairy princess riding on the white bird's back. Other floats included Old King Cole; Pussy in the Well; Peter Pan; Willie the Whale; Peter, Peter, Pumpkin Eater; Puss 'N Boots; and the Old Woman Who Lives in the Shoe (below). Decorations were hung downtown four days before the parade, as seen in the photograph above, to create a fanciful backdrop for the feathered matron and her friends. (Both, photograph by Howard Hopkins, courtesy of Dewey F. Bartlett Jr.)

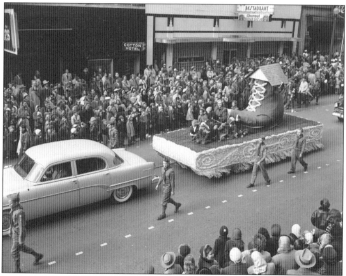

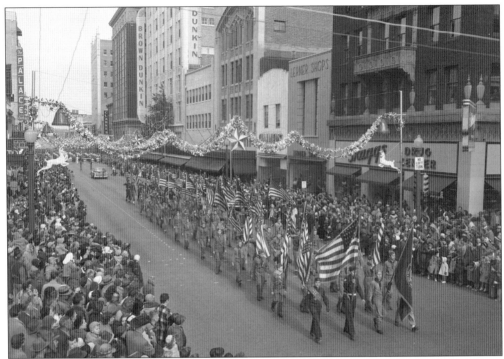

Four hundred Boy Scouts took part in the 1953 parade, including an honor guard of 87 Boy Scouts carrying American flags (above), one for each county's troops, as well as flags representing the 55 free nations of the world in 1953. Below, a float bearing an unstable barn containing two of the king's horses sits behind a wall where Humpty Dumpty precariously perches. He is followed by a troop of Scouts dressed as "All the King's Men," leading the way for Santa's float. (Both, photograph by Howard Hopkins, courtesy of Dewey F. Bartlett Jr.)

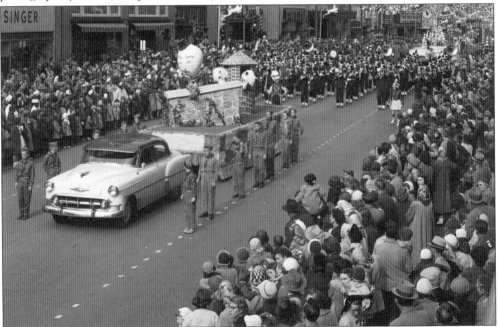

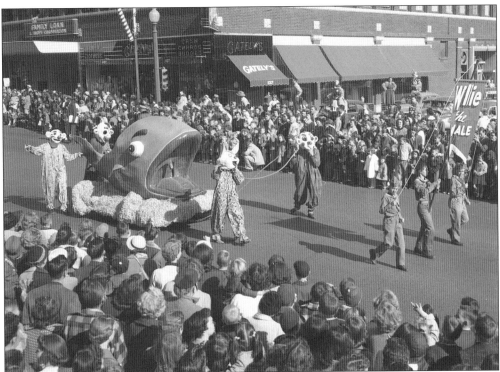

Eleven floats, all with nursery rhyme themes and each one with animated parts, glided down the route at the 1954 parade. Some were favorites that were returning, such as Willie the Whale (above), and some were new, such as the Ugly Duckling (below), which featured an animated duckling that bobbed up and down and waved, a large bullfrog, and a pelican. Another new float that year was Hey, Diddle Diddle, the Cat and the Fiddle. (Both, photograph by Howard Hopkins, courtesy of Dewey F. Bartlett Jr.)

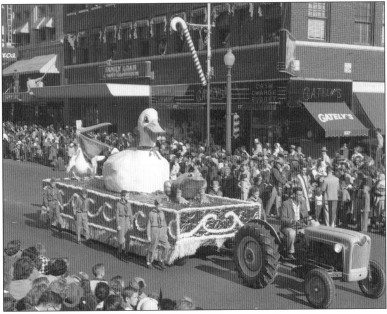

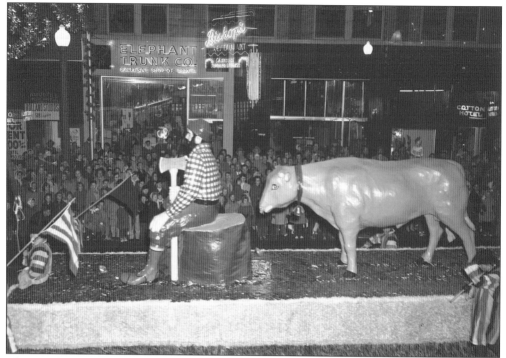

The parade committee tried to bring a bit of Hollywood to the 1955 Yuletide Pageant. Eighty clowns, as well as parade walkers dressed in either grotesque head costumes or top hats and tuxedos imported from Columbia Pictures, escorted the floats and bands down the parade route. Seen above is Paul Bunyan's 10-foot-tall, three-ton float carrying a bull called Bluestem Babe. After the parade, the committee submitted the bovine for a roll in the musical comedy *It Happened One Night*. Below, the first float of the parade, called the Carolers, had a real, remote-controlled pipe organ that played music for a choir of 16 young girls. (Both, photograph by Howard Hopkins, courtesy of Dewey F. Bartlett Jr.)

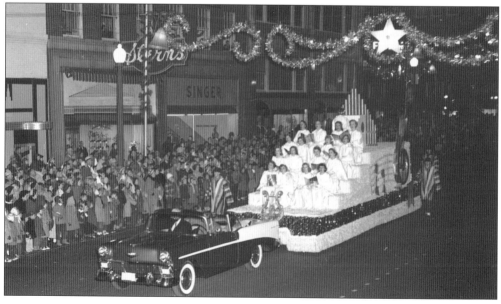

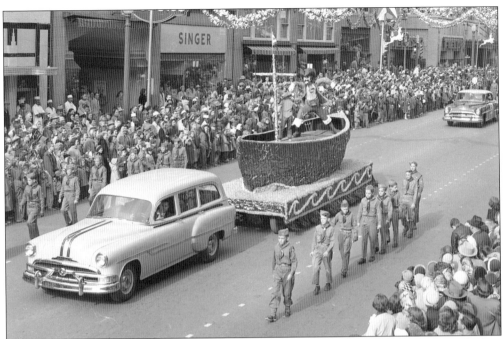

Many favorite floats were brought back several years in a row. Here, a float with a pirate guarding his ship is seen in the 1953 parade (above) and the 1955 parade (below). In 1955, the parade had 37 entries: 11 floats and 13 bands totaling 1,200 marching musicians, 10 of which were from small communities outside of Tulsa, including Okmulgee and Nowata. One eleventh-hour entry, the Norse Stars Drill Team, from Northeastern Oklahoma A&M College in Miami, Oklahoma, was admitted to the parade the day before the event took place. (Both, photograph by Howard Hopkins, courtesy of Dewey F. Bartlett Jr.)

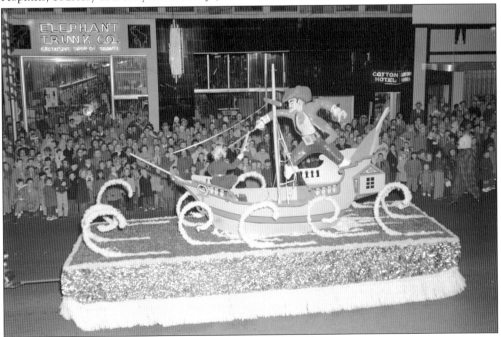

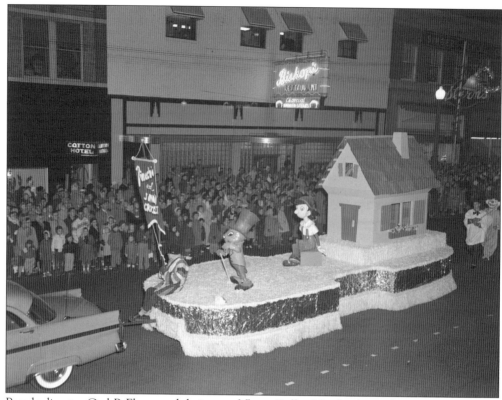

Parade director Carl P. Flynn and designer of floats Dallas Meade planned a route for the 1955 parade that stretched as far south as West Ninth Street and traveled along Main Street and Boston Avenue. It was the first parade to be held in the evening in over 20 years. The mobilization headquarters and staging area was at North Main Street between West Cameron and Easton Streets. Downtown stores were closed, and the Tulsa Police Department helped ensure the safety of the impeding crowds and blocked off the route starting in the midafternoon. Police traffic captain Larry Coulson told the *Tulsa World* that the parade was the largest he had handled in his career of working parades and the crowd was so large that it had to be pushed back and it "took quite a while untangling traffic before and after it was over." (Both, photograph by Howard Hopkins, courtesy of Dewey F. Bartlett Jr.)

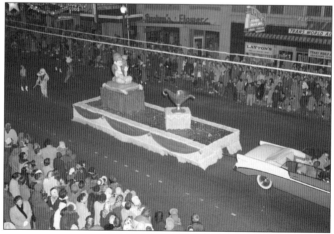

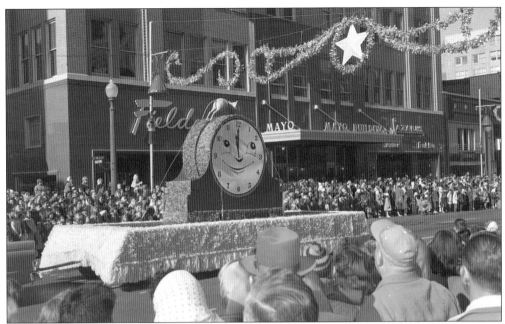

At the parade on November 18, 1956, the stars of the floats were Mother Goose characters that had been popular for several years. That year included Simple Simon, Old King Cole, and Hickory Dickery Dock, which is seen above. The parade traveled a 22-block route and was led by a float of the nativity scene, seen below, which set out from the staging area at the Tulsa Convention Hall, at North Boulder Avenue and West Brady Street, starting at 10:00 in the morning. (Both, photograph by Howard Hopkins, courtesy of Dewey F. Bartlett Jr.)

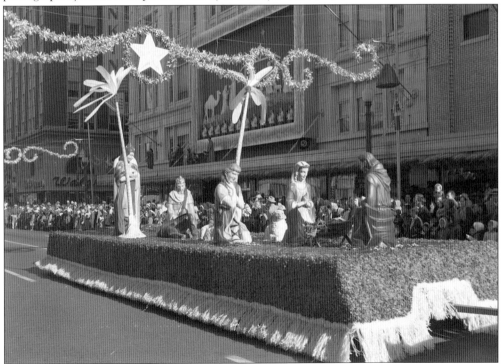

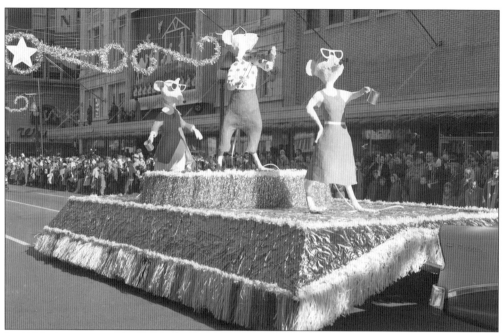

In 1956, the nation was reeling from a recent rise in rock 'n' roll music. To capitalize on this popularity and publicize the Yuletide Pageant, the parade committee crafted a catty controversy of cleverly concocted puns between Santa Claus and the storybook characters headlining that year's parade. These witty promotions were published in *Tulsa World* the week of the parade. The Three Blind Mice led the charge to replace carols with croons, with the head mouse, Elvis Mousely (in the middle of the float above), saying he would play "You Ain't Nothing But a Field Mouse" instead of "Jingle Bells" during the parade. Santa responded saying he would set a trap if the mice stirred up trouble. Little Boy Blue, sleeping soundly in the photograph below, was also in support of the swinging songs, saying he would slip on his blue suede shoes Saturday morning because "Christmas weather is cool, man, and you got to have cool music." (Both, photograph by Howard Hopkins, courtesy of Dewey F. Bartlett Jr.)

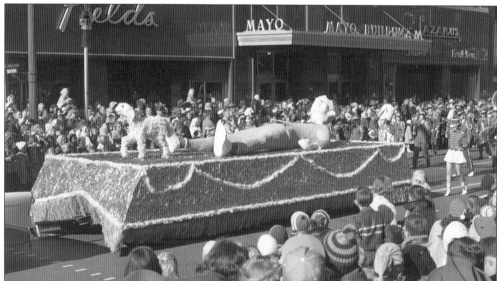

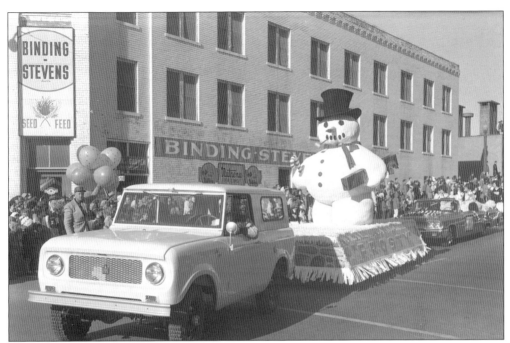

In 1963, floats built for the parade, such as the Old Woman Who Lived in a Shoe and Frosty the Snowman, seen on South Boulder Avenue above, had been loaned to a Christmas parade in Oklahoma City the Friday night before the Tulsa parade. Due to issues with some vehicles, the floats almost did not make it back to Tulsa in time for the parade. Thankfully, several members of the Coast Guard Auxiliary stepped up and helped tow the floats home just in time. Frosty was very popular and came back for an encore in 1965, seen below. (Both, photograph by Howard Hopkins, courtesy of Dewey F. Bartlett Jr.)

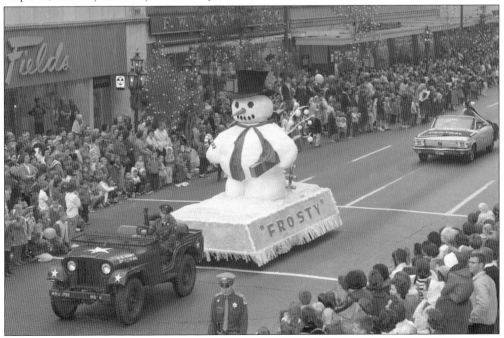

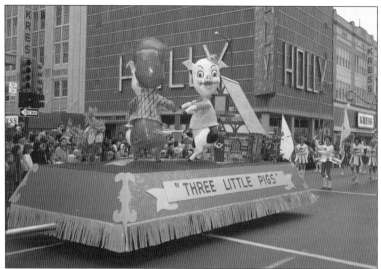

The Three Little Pigs dance in a circle on their float to celebrate the brick house of the Third Little Pig withstanding the huffs and puffs of the Big, Bad Wolf as they pass in front of Holly, a department store on South Main Street, during the 1965 parade. (Photograph by Howard Hopkins, courtesy of Dewey F. Bartlett Jr.)

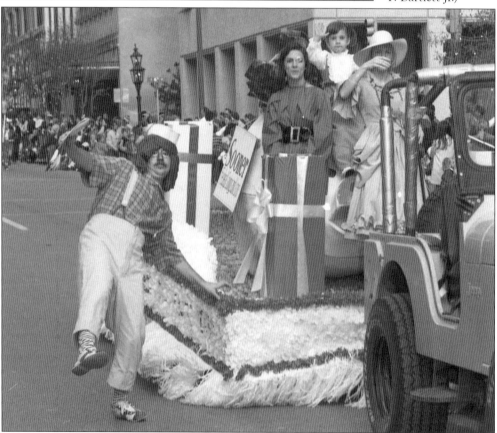

By the 1970s, many businesses, churches, and community groups were entering floats in the parade to complement the floats built by the parade committee each year. The parade in 1974 drew entries from a three-state area and over 180 units totaling 7,000 people participating in the parade. Here, an entry from Sooner Federal Savings and Loan is escorted by a tripping clown. (Photograph by Howard Hopkins, courtesy of Dewey F. Bartlett Jr.)

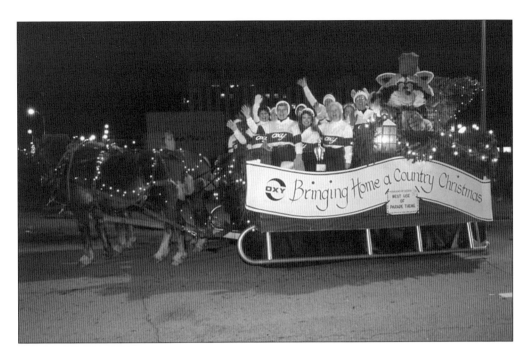

Since the 1980s, the parade board has encouraged creative design for floats in the parade by giving awards to entries for categories such as Best Costumes and Best Overall. Above, Occidental Petroleum won the award for Best Use of Parade Theme, "A Country Christmas," with its horse-drawn sleigh. Below, Owen-Brockway Glass from Muskogee, Oklahoma, won Best Use of Lights for a commercial entry for its train float at the December 10, 1988, parade. (Both, courtesy of Downtown Tulsa Unlimited.)

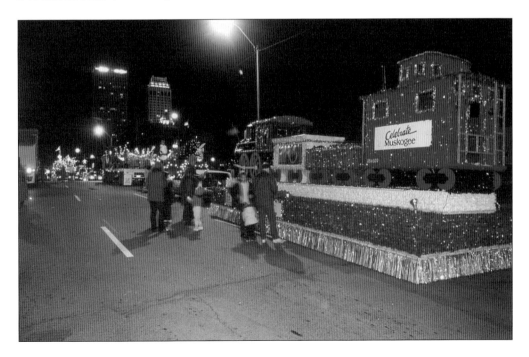

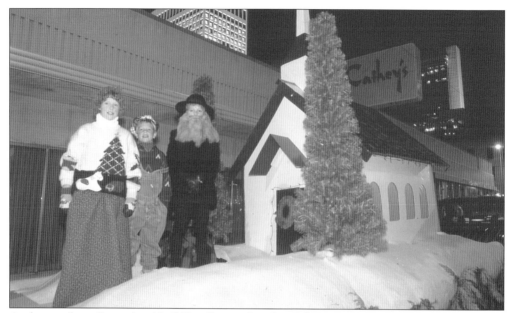

At the parade on December 10, 1988, a float with a church house and children dressed in costumes of old-fashioned clothing waits for its turn to roll down the route. In the background, above the church house, a sign reading "Cathey's Fine Furnishings" can be seen. George T. Cathey owned a small furniture store on East Second Street before opening Cathey's Fine Furnishings at 816 South Main Street in 1931 with his nephew George R. Cathey. The store moved several times in the 1980s and eventually closed in the 1990s. (Courtesy of Downtown Tulsa Unlimited.)

A float designed and built by the employees of presenting sponsor American Waste Control rocks down the route at the 2015 parade. Titled Blue Christmas, it featured an Elvis impersonator crooning to the famous song of the same title. (Photograph by Brett Rojo, courtesy of *Tulsa World*.)

Six

O COME ALL YE FAITHFUL

Starting with the very first parade in 1926, crowds have always numbered in the tens of thousands each year. In the middle part of the 20th century, starting in the 1950s, that number grew to 200,000 or more each year. Seen here are crowds from the 1949 parade. (Photograph by Howard Hopkins, courtesy of Dewey F. Bartlett Jr.)

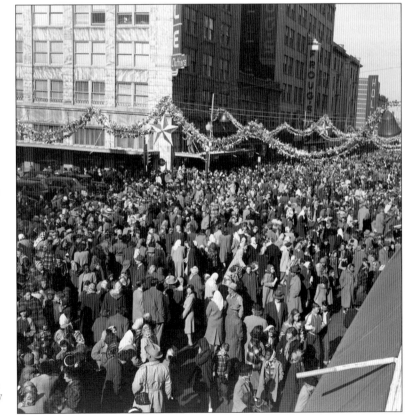

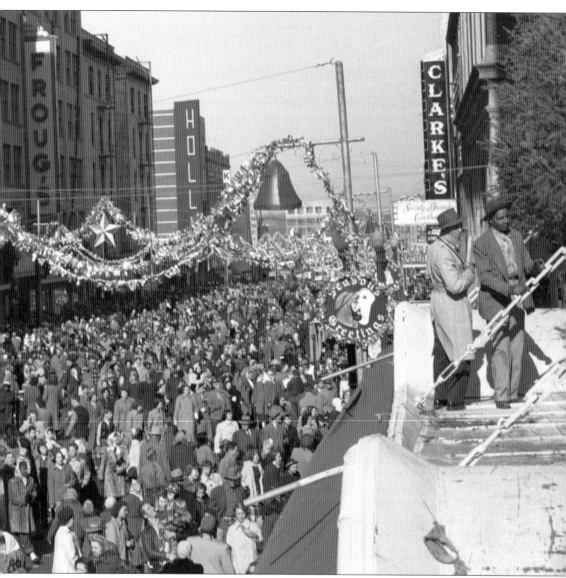

The day before the 1949 parade, the *Tulsa World* reported that 100,000 people were predicted to turn out to watch the procession. The three years prior, crowds had hovered around 75,000–100,000, even with snow the day of the parade in 1947. But in 1949, the crowds doubled in size, with estimates of 180,000 spectators coming out to greet Santa. People started traveling downtown at sunup to avoid crowds. By 9:00 a.m., an hour before the parade started, traffic around the downtown area was at a standstill, with the congestion lasting until several hours after the parade had ended, making even walking difficult while people tried to get into restaurants, cafeterias, and local retails shops. Here, two men appear to test the strength of the supports holding up the awning on the front the Brown-Dunkin department store during the parade on November 25, 1949. (Photograph by Howard Hopkins, courtesy of Dewey F. Bartlett Jr.)

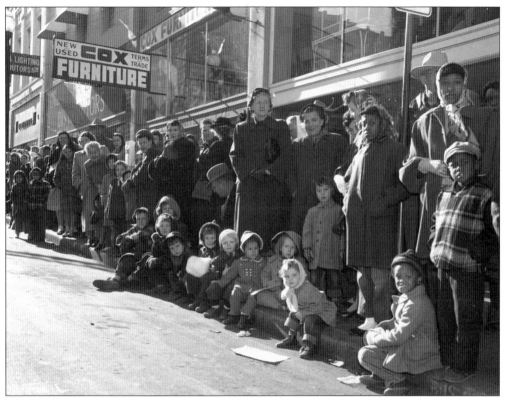

Above, families huddled together wait for the 1949 parade to start. Several of the small children have grown tired of standing and make use of the curb as they wait. The streets were completely filled over an hour before the parade started at 10:00 a.m. Below, a young man amidst the crowd, with his ice skates slung over his shoulder, gets a handshake from a person dressed up in a large, donkey head costume. Most of the animals at the parade were people in costumes, with the exception of live camels brought in from McAlester, Oklahoma, for the Three Wise Men float. (Both, photograph by Howard Hopkins, courtesy of Dewey F. Bartlett Jr.)

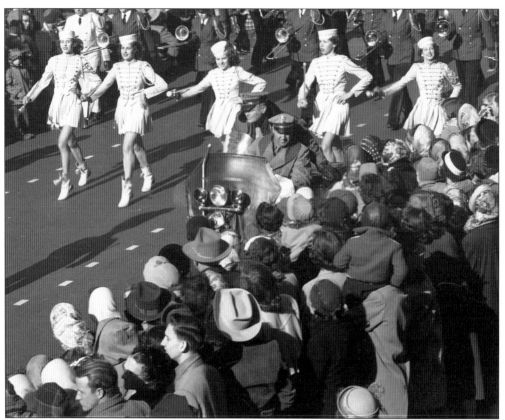

Crowds pushing forward in an attempt to get the best view of the passing floats, bands, and balloons has been a reality of the parade since it began. Safety is the primary concern for the officers from the Tulsa Police Department, who assist parade board members at the event every year. Above, two officers attempt to hold back the crowds at the parade on November 25, 1950, as majorettes twirl their batons and lead a band down the street. Below, one of the 40 Tulsa traffic officers at the 1953 parade on a motorcycle helps remind the crowd to stay behind the lines as the parade passes. (Both, photograph by Howard Hopkins, courtesy of Dewey F. Bartlett Jr.)

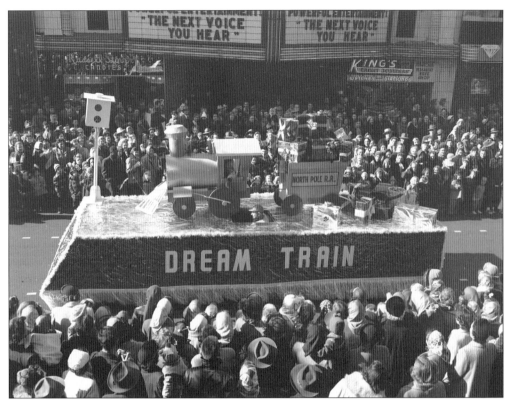

This group pushing in to get the best view of the parade as it floats down South Main Street represents just a small fraction of the 200,000 people that crowded the streets for the 1950 parade, setting a new record for the highest attendance in the parade's history. In November 1950, the city of Tulsa was experiencing a bus strike, so a private company, Dawson Bus Line, stepped in to provide transportation to parade goers trying to get downtown. Its buses picked up passengers at several spots along North Yale Avenue. The buses were not allowed to stop for passenger pickups within Tulsa city limits, however, causing thousands to attempt to drive downtown and creating enormous traffic congestion lasting up to two hours after the parade ended. (Both, photograph by Howard Hopkins, courtesy of Dewey F. Bartlett Jr.)

At West Fourth and South Main Streets, the Palace Clothiers building, constructed in 1913 by Simon Jankowsky, was a prime location for parade viewing. Malcolm Milsten (not shown), Jankowsky's grandson, remembers watching many parades from the awnings of his grandfather's building. Jankowsky, a Russian immigrant to America in 1882, was a Tulsa pioneer who opened Palace Clothiers in 1904. His family owned and operated the business for over 50 years until it closed in 1960. Above and below, two separate groups of people, likely friends and employees of the Jankowsky family, are bravely perched on two awnings at Palace Clothiers, primed for a top-row view of the 1950 parade. Today, the building has been converted into Palace Apartments and several of its original interior and exterior features are still intact. (Both, photograph by Howard Hopkins, courtesy of Dewey F. Bartlett Jr.)

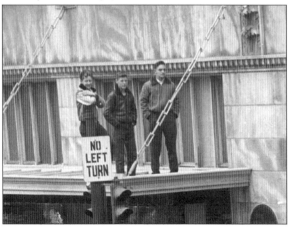

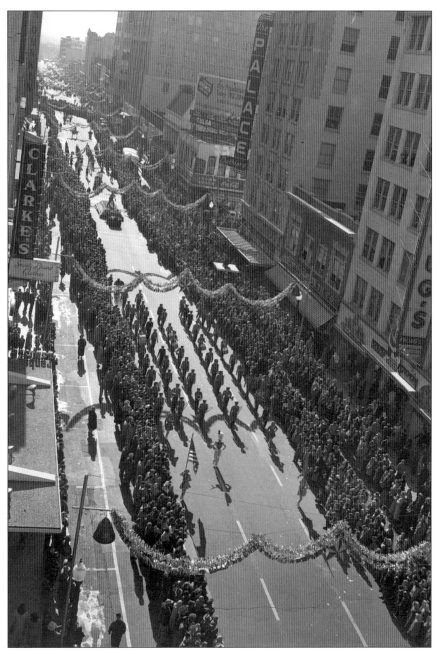

A billboard for the Tulsa Chamber of Commerce, on the right, just behind the Palace Clothiers sign, lists current demographics for Tulsa as it overlooks the parade on November 22, 1952. The billboard brags that Tulsa's population at the time is 193,284 and notes that this number is a growth of 51,000 since 1940. Most of that population growth occurred after World War II ended in 1945. The sign also notes other interesting facts about Tulsa in 1952, such as 35,102 new telephones; 18,355 new electric customers; and 10 million more gallons of water used every day. *Tulsa World* reported that parade attendance was nearly 200,000 in the early 1950s. These figures indicate that the vast majority of Tulsa's population came out to watch the parade each year. (Photograph by Howard Hopkins, courtesy of Dewey F. Bartlett Jr.)

In the 1950s, the Tulsa Red Cross Motor Service provided transportation to the parade for children from local hospitals and children's homes. A special area was reserved for them on the front porch of the Elks Club, at 302 South Boulder Avenue. (Photograph by Howard Hopkins, courtesy of Dewey F. Bartlett Jr.).

Twenty-two-month-old Kenneth Foshee drinks his bottle while sitting next to his three-year-old sister Patricia (left) at the 1954 parade. The over 200,000 people that came out to see the parade in 1954 jammed all major streets and highways leading to Tulsa for nearly two hours before the parade started at 10:30 a.m. (Photograph by Howard Hopkins, courtesy of Dewey F. Bartlett Jr.)

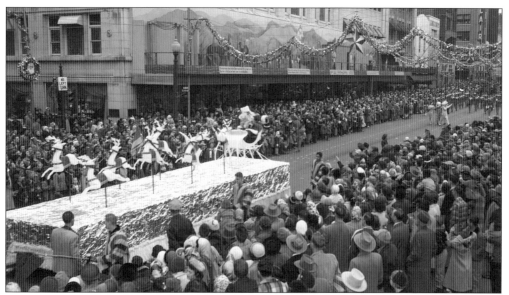

Harry Felactu and his wife watched the 1952 parade and clapped enthusiastically as their son Jimmy passed by with the Will Rogers High School Marching Band, one of the many bands at that year's parade, seen behind Santa's float above on South Main Street. Felactu claimed it was the "best parade" he had seen in years and reminded him of "a parade in New York." As seen in the both images, people lined the streets and sidewalks all along the route, in most places 10–15 deep. Most years, to get the best vantage point, people scaled lampposts, hung out of office windows, and climbed rooftops. Some brave young boys were even spotted clinging to the top of a traffic light. (Both, photograph by Howard Hopkins, courtesy of Dewey F. Bartlett Jr.)

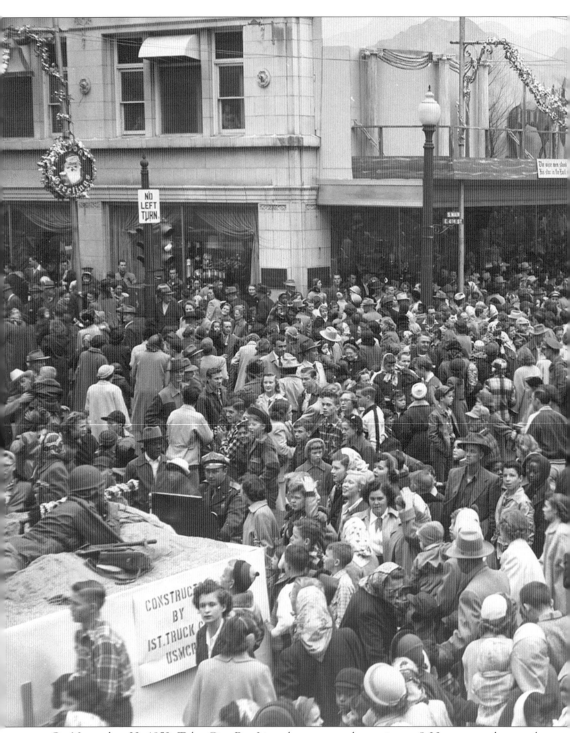

On November 22, 1952, Tulsa City Bus Lines buses started running at 8:00 a.m. to take people downtown for the 10:30 a.m. parade start time. The buses started on the edges of town and were filled to capacity before even making it halfway downtown, so many residents living closer to the parade route had to walk, as finding parking was nearly impossible. One *Tulsa World* reporter

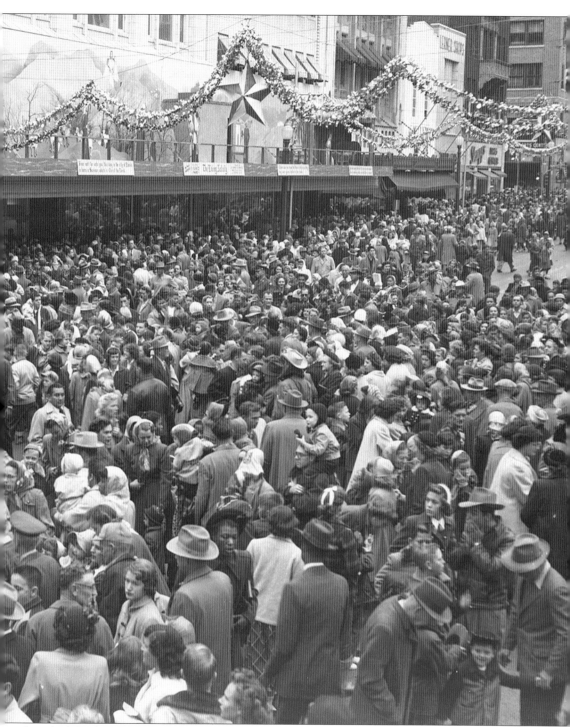

described the downtown district like a "giant reservoir . . . filling with people" and said the crowds of people on West Fifth Street, between South Boulder Avenue and South Main Street, were like a "surge of . . . water gushing out of a ruptured dam" as they spilled over the curb and into the streets. (Photograph by Howard Hopkins, courtesy of Dewey F. Bartlett Jr.)

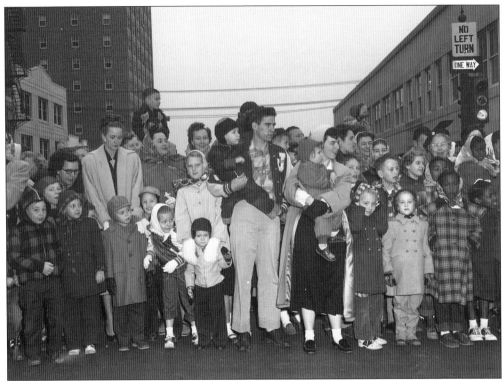

Police traffic director Larry Coulson estimated there were 200,000 people in attendance at the 1952 parade, which started heading south from the Tulsa Convention Hall at North Boulder Avenue and West Brady Street, and he said he witnessed many children run through alleyways to get a second view of the parade after it turned and headed back north on South Main Street. (Both, photograph by Howard Hopkins, courtesy of Dewey F. Bartlett Jr.)

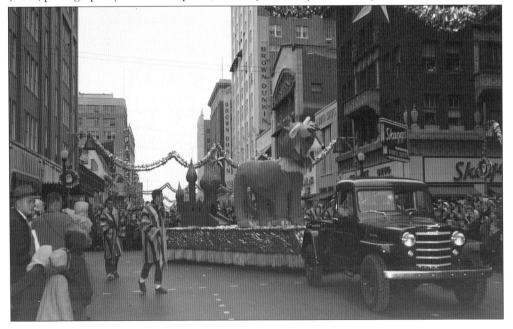

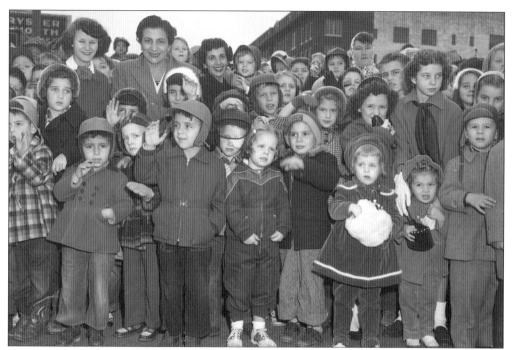

Over 200,000 people lined the streets at the parade on November 21, 1953. A redesigned route was rolled out to accommodate the thousands of visitors to the parade. Carl P. Flynn, parade manager, explained to the *Tulsa World*, "This will allow thousands more people a better view of the parade." (Photograph by Howard Hopkins, courtesy of Dewey F. Bartlett Jr.)

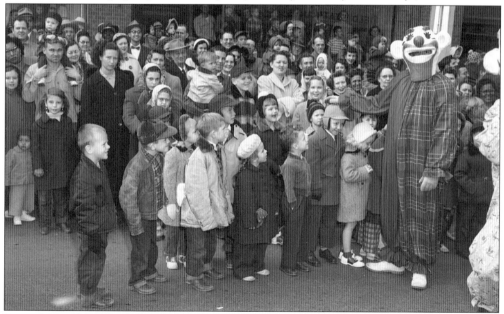

Forty clowns, like those seen here, walked among the crowds, as well as 40 Tulsa traffic officers, who were assisted by reinforcements of county patrolmen and Oklahoma Highway Patrolmen in order to keep the thousands of people safe. Ambulances were staged throughout the route as well in case of emergencies. (Photograph by Howard Hopkins, courtesy of Dewey F. Bartlett Jr.)

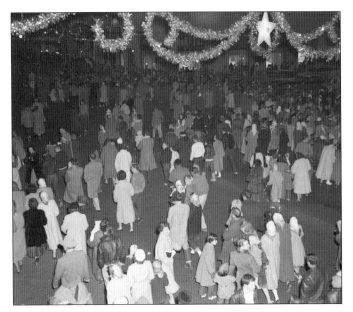

On Tuesday, November 29, 1955, the parade was held at night for the first time in more than 20 years. Even the chilly temperatures, which dipped into the 20s, did not detract crowds of over 100,000 people flocking towards the front lines under grand displays of garland and stars. A cold front with temperatures in the teens and 60-mile-an-hour winds damaged decorations a few days before the parade, but they were quickly repaired for the big night. (Photograph by Howard Hopkins, courtesy of Dewey F. Bartlett Jr.)

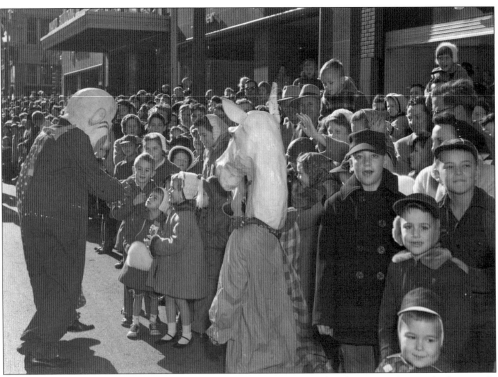

In 1956, the parade twisted and turned through downtown Tulsa for two miles, with thousands of delighted viewers lining the streets to cheer on the many marching bands and see floats that were designed around Mother Goose characters. Costumed characters such as clowns and animals mingled among the elated children waiting for the parade to commence, with the children gleefully greeting them and asking questions. (Photographs by Howard Hopkins, courtesy of Dewey F. Bartlett Jr.)

Space along the parade route is a precious commodity, and people search for new and creative ways to get the best view each year. Here, at the 1965 parade, a woman and young boy share a ladder to raise themselves a head above the rest of the crowd watching the action of the Little Toy Soldiers float pass down South Main Street. Next to them, a man gives each of his shoulders for two children wanting a better view. (Photograph by Howard Hopkins, courtesy of Dewey F. Bartlett Jr.)

Warm weather on November 23, 1974, prompted many in the crowd of over 200,000 to wear short sleeves while they watched the two-hour parade. To help alleviate traffic congestion nearest the parade route, free parking was offered at the Civic Center a few blocks from the parade. (Photograph by Howard Hopkins, courtesy of Dewey F. Bartlett Jr.)

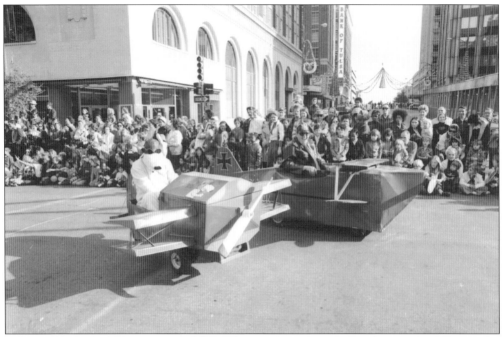

Tulsa World reported that Snoopy and the Red Baron from the 1974 parade were almost as popular as Santa and drew "squeals of delight" from the crowds as they flew down the parade route. They are seen at the corner of East Third and South Main Streets in front of a building known today as the Reunion Center, originally constructed in 1917. (Courtesy of *Tulsa World*.)

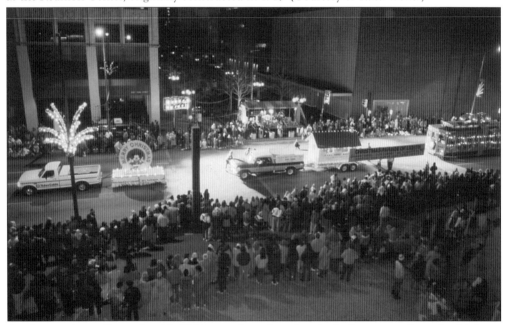

At the parade on December 10, 1988, crowds gathered early for live music from the Dickens Carolers, Tulsa Boy Singers, and Washington High School Honor Girls Chorus, as well as other activities that were planned at the Samson Plaza in the Main Mall area, at Third and South Main Streets, before and after the parade. (Courtesy of Downtown Tulsa Unlimited.)

Seven

SANTA CLAUS IS COMING TO TULSA

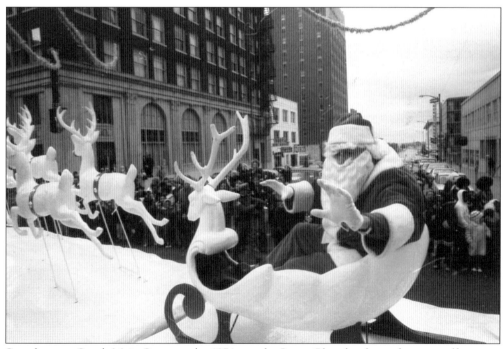

Seen here on South Main Street at the 1974 parade, Santa Claus has been the guest of honor at the Tulsa Christmas Parade since the first year in 1926, when the *Tulsa Tribune* printed several telegrams from him prior to the parade informing Tulsans on his preparations to visit their town. For many years after the first parade, *Tulsa World* carried on this tradition of "interviewing" Santa the week before the parade. (Courtesy of *Tulsa World*.)

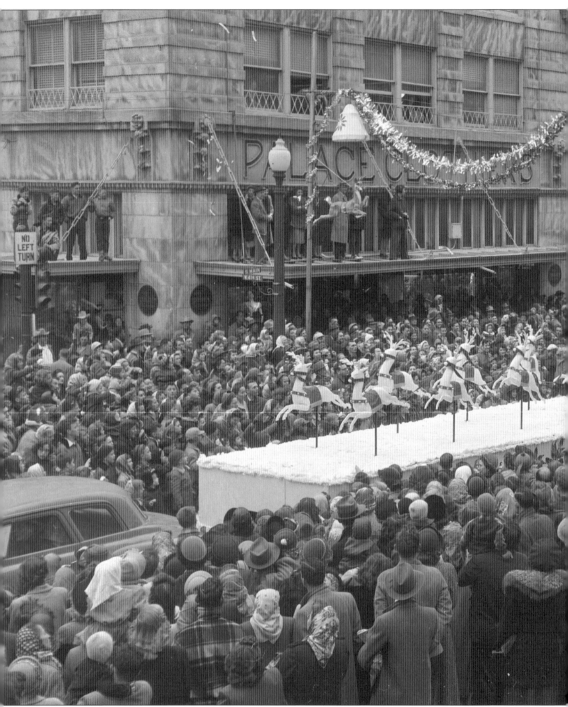

Santa's float is greeted with cheers and applause as it pushes through the crowds of thousands at the parade on November 24, 1951. Weather forecasts of rain and sleet did not deter the throng of almost 250,000 people from lining the route starting at 7:30 that morning, three hours before the procession commenced, hoping to get the best view of Santa and other storybook stars headlining the parade that year. While nearly every Tulsa resident was downtown watching the celebration

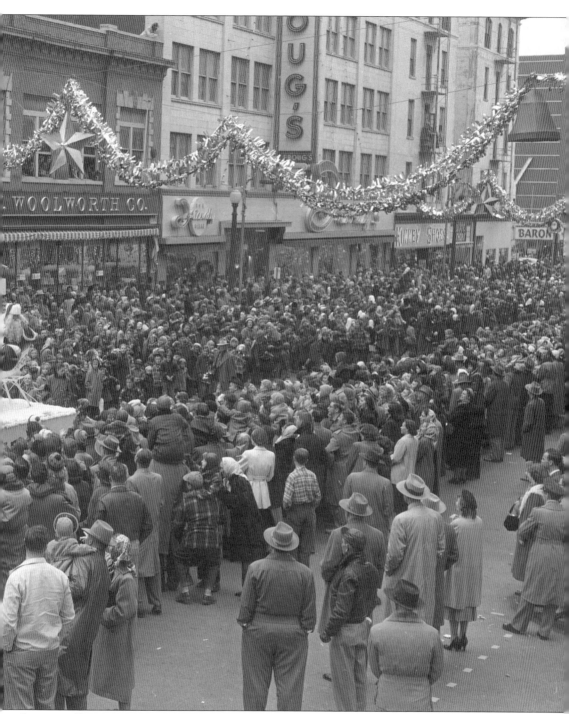

live, as well as estimates of up to 75,000 people that traveled from outside of Tulsa to enjoy the parade on the long Thanksgiving weekend, those that could not attend were able to watch on television for the first time, as reported by *Tulsa World*. (Photograph by Howard Hopkins, courtesy of Dewey F. Bartlett Jr.)

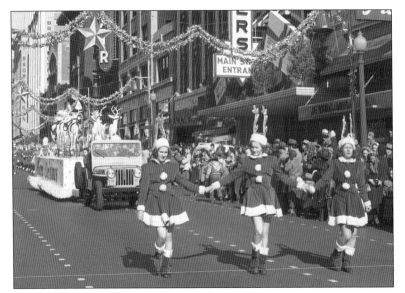

Three of Santa's helpers hold hands as the crowds hail the holiday hero as he passes down South Main Street during the parade on November 26, 1949. City hall closed its doors at 10:00 a.m. to allow its employees to attend the parade instead of work. (Photograph by Howard Hopkins, courtesy of Dewey F. Bartlett Jr.)

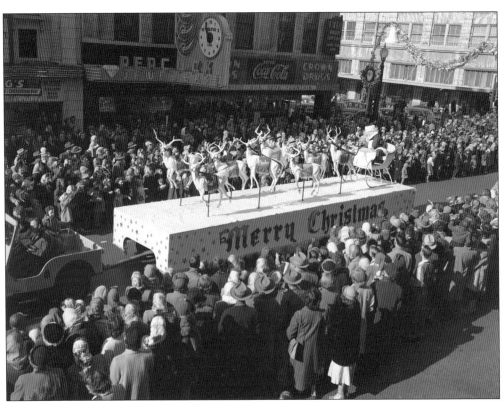

Santa is seen at the 1950 parade riding his sleigh down South Main Street. Two days before the parade, Thanksgiving had ushered in below-freezing temperatures, reaching a record low of 14 degrees by Friday morning. But a nice warm-up brought temperatures to nearly 50 degrees for the parade at 10:30 a.m. on Saturday morning. (Photograph by Howard Hopkins, courtesy of Dewey F. Bartlett Jr.)

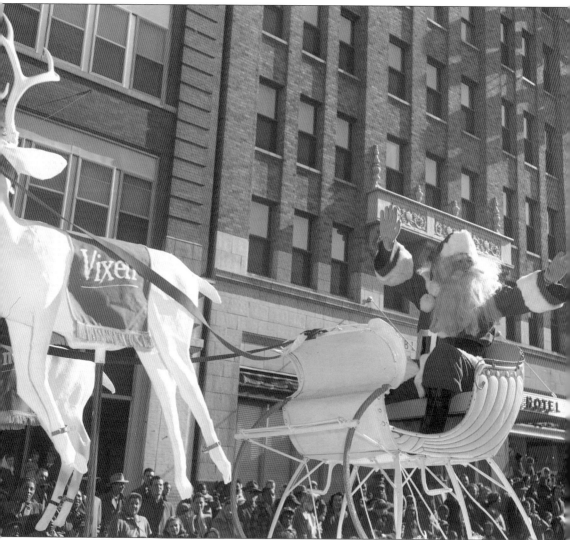

Thirty fairyland balloon characters were brought in from Chattanooga, Tennessee, the Friday night before the 1949 parade on a charted air freighter that was greeted at Tulsa Municipal Airport by a large crowd. Articles in the *Tulsa World* a few days before the parade reported rumors that live polar bears might be among the special guests brought in and would accompany Santa as he traveled the route. The source of the rumors, an article noted, was traced to a couple of local lads who had overhead parade committee members discussing plans for parade preparation. However, this rumor was quickly doused out when Tulsa Retail Trade Board Sponsorship Committee secretary R.O. Rayson pointed out the boys mistook "barricades" for "bear cages" and Santa's float would be escorted by eight animated reindeer instead. When Santa's turn in the 46-unit parade came, he and his reindeer were led in by the marching band from Central High School playing "Santa Claus is Coming to Town." (Photograph by Howard Hopkins, courtesy of Dewey F. Bartlett Jr.)

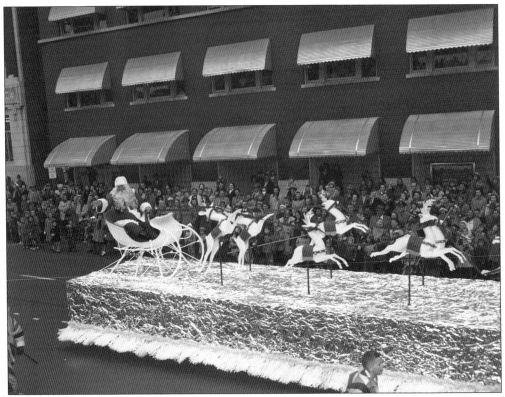

Tulsa World reported that Santa had a blackboard set up in his shop with a note reminding him, "Go to Tulsa Nov. 22" so that he would not forget to be at the parade on November 22, 1952. Santa also told the *Tulsa World* that he had a road map of Oklahoma so he would not get lost and delay the parade. He went on to say he would be wearing a space helmet and flying 20 miles above the surface of the earth for two reasons—so no one would see him and so his reindeer would not stub their hooves on a cloud. But he said that was as far as he would take it with the new inventions as he relied on his reindeer team, which had been flying with him for over 1,000 years, more than any jet plane. (Both, photograph by Howard Hopkins, courtesy of Dewey F. Bartlett Jr.)

Eight-month-old Edmond Ray Gifford was a lucky little lad as he got to sit in Santa's lap for a photograph at the 1953 parade, at the intersection of East Sixth and South Main Streets. Santa had a new float, much larger than in previous years, in all white, with eight animated reindeer that bobbed up and down to mimic flying. (Photograph by Howard Hopkins, courtesy of Dewey F. Bartlett Jr.)

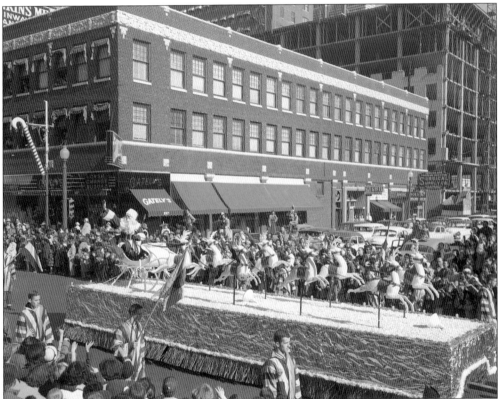

At the last minute, an extra block of South Main Street, between East Eighth and East Ninth Streets, was added to the route of the 1954 parade so that several buses of physically handicapped children could have an easily accessible place to see Santa from the windows of the buses. Santa is seen here on South Main Street. (Photograph by Howard Hopkins, courtesy of Dewey F. Bartlett Jr.)

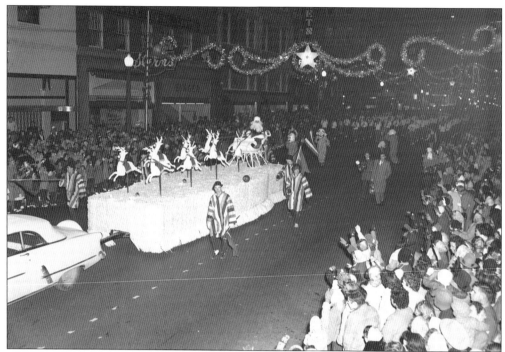

Along with 4,000 lights decorating the route, including 5,000-watt floodlights, Santa had a path of blazing Christmas lights instead of a red carpet as in years past. Santa was the last entry, following the Central High School band playing "Here Comes Santa Claus." Tulsa Building Owners and Managers Association secretary Walter C. Deppe reported all exterior windows of skyscrapers and office buildings (over 40 in all) kept their lights on to help illuminate the route—a first in Tulsa history. A full moon was also on display to contribute to the illumination efforts. (Photograph by Howard Hopkins, courtesy of Dewey F. Bartlett Jr.)

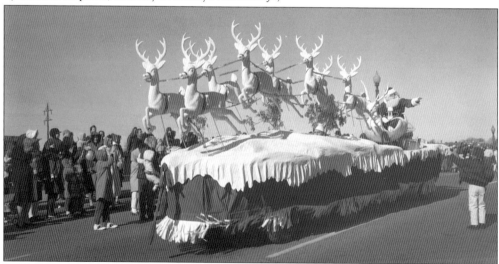

In 1963, Santa had a brand-new, 26-foot-long float covered in snow and icicles for him and his eight reindeer. As he passes down South Boulder Avenue, Santa is seen waving to a young boy who has stepped out into the street to get as close to the merrymaker as possible. (Photograph by Howard Hopkins, courtesy of Dewey F. Bartlett Jr.)

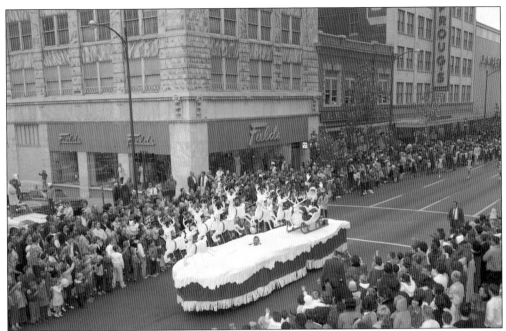

Santa Claus passes down South Main Street in front of the Palace Building, at 324 South Main Street. Home to Palace Clothiers from 1913 to 1960, the Palace Building was occupied by Field's Department Store at the time of the 1965 parade. The building was renovated from 2015 to 2017 and is now apartments. (Photograph by Howard Hopkins, courtesy of Dewey F. Bartlett Jr.)

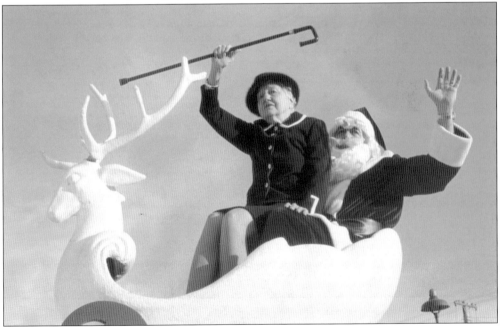

Lucille Tinney, the 84-year-old mother of Santa Claus in Tulsa's big parade in 1974, sits on her son's lap atop his sleigh. She flew to Tulsa from California to see her son in the annual Christmas parade. During the parade, she rode in a van behind Santa's float. Santa's secret identity was Tulsan H.L. Moss. (Photograph by Johnny Walker, courtesy of *Tulsa World*.)

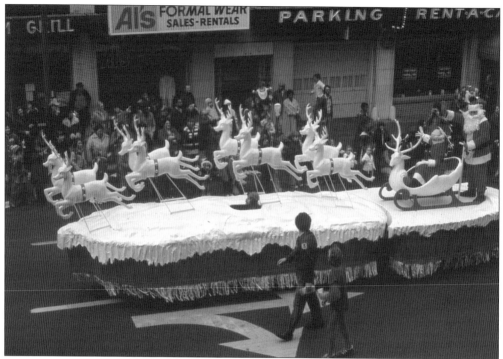

Santa's float rolls down South Boulder Avenue at the parade in 1979. The float, with careful maintenance, had been in use since 1963. (Courtesy Downtown Tulsa Unlimited.)

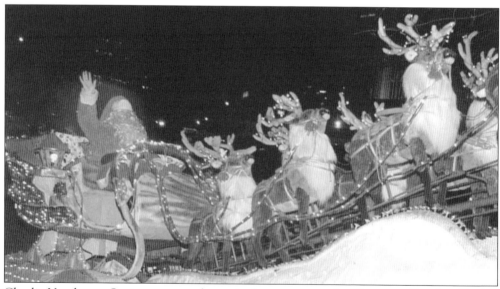

Charlie Vaughn, as Santa, waves to the excited spectators at the Christmas Parade of Lights on December 12, 1997. Wishing all a merry Christmas, Santa was the last float in the lineup. (Photograph by John David Heckel, courtesy of *Tulsa World*.)

Eight

CHRISTMAS PAST, PRESENT, AND FUTURE

Throughout the past nine decades, the Tulsa Christmas Parade has been witness to many important historical events. And while many aspects of the parade have changed since 1926, some things—like the enthralled children and fun family memories—will always stay the same. Looking back on history and spotting similarities decades apart through the eyes of the parade, such as these children in 1953 fighting for the best view of the parade on a father's shoulders (or even head), shows where Tulsa has come from and gives a possible glimpse into its future. (Photograph by Howard Hopkins, courtesy of Dewey F. Bartlett Jr.)

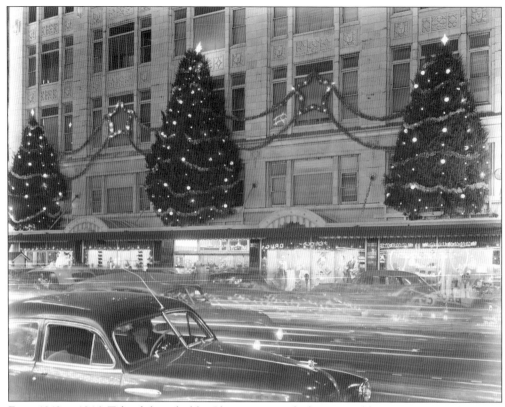

From 1942 to 1946, Tulsa did not hold a Christmas parade due to World War II. During this time, Tulsans came together to support the war and keep their community strong despite the hardships. And they still came together to celebrate Christmas and decorate downtown each year with garland, trees, and lights, as seen here in the 1940s in front of the Brown-Dunkin building on South Main Street. (Photograph by Howard Hopkins, courtesy of Dewey F. Bartlett Jr.)

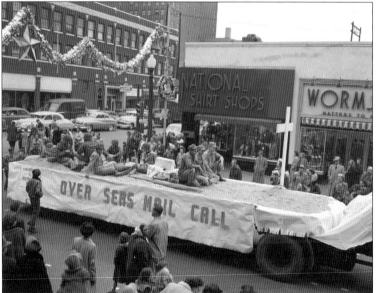

Titled Over Seas Mail Call, this float carrying soldiers is decorated with a white cross and bags of mail marked "from home," reminding 1952 parade goers that this was the third Christmas soldiers would be away from home in the Korean War. (Photograph by Howard Hopkins, courtesy of Dewey F. Bartlett Jr.)

TULSA DAILY WORLD

Country Parson
"The underdog is the one likely to be doing most of the biting."

News Department—Tel. LUther 3-2161 TULSA, OKLAHOMA, SATURDAY, NOVEMBER 23, 1963 Want Ads—LUther 3-2121

Tears, Silence, Disbelief Follow Tragedy *Children Pray in School Chapel* *'Could Such a Thing Happen in U.S.?'*

Tulsans Stunned as Assassination News Spreads

By GEORGE KANE
Of The World Staff

Tulsans reacted grimly to the death of President John F. Kennedy in Dallas Friday.

Stunned disbelief, followed in many instances by tears—some from the eyes of men—moved over Tulsa as business downtown slowed to a shocked stop.

"I feel ashamed that any American would think of such a thing, let alone carry out the assassination," said merchant Harry Clarke Jr.

"My reaction, the reaction of everyone in my store, was one of amazement that such a thing could happen in the United States," he said.

"Our whole political system," said insurance man Jack Mandeville, "is based on opposite political views. Mine have always been contrary to the President's.

"But this is a complete breakdown of that system. This is a ghastly thing that has happened."

Mayor James L. Maxwell, attending a luncheon at the Alvin Plaza Hotel, was informed of the Dallas shooting shortly before 1 p.m.

He and other commissioners immediately left the hotel to return to City Hall.

As he entered his office, CBS News announced unofficially that President Kennedy had just died.

"My God," the mayor said softly.

At 1:45 p.m., Mayor Maxwell conferred with other city commissioners and directed City Hall be closed at 2 p.m.

In a statement to newsmen at 1:50 p.m., the mayor said, "This is a great shock and a great loss to the nation. My first reaction was one of complete disbelief.

"We couldn't believe the information given us (at the hotel) was correct.

"Everyone feels, I am sure, the great tragedy of the President's death. I feel a lack of words at the news. I'm sure everyone in Tulsa and across the country feels the same."

As the news spread over the downtown area, blanketed under rainclouds, stillness became prevalent as death. No horns sounded and no one spoke. A few persons nodded to each other, but no one smiled.

Children in classes at Immaculate Conception School were informed of the shooting about 12:45 p.m. They filed into the chapel and were led in a rosary, for the recovery of the President, by the

Rev. Daniel Cawthon, assistant to the pastor of the parish.

They returned to classes later and were informed the President had just died. Students and Sisters met the news with shock, then one of the teachers, a nun, began to cry. It was infectious.

A visitor in Tulsa, stopped at random on the street and asked about news of the President's death, said: "How could it happen now? It must have been carefully thought out and planned. But, how could it happen?"

The speaker was a Negro church leader from Las Vegas—Bishop Cox of the Church of God.

On Main Street, a teen-age girl listened to a transister radio. Tears lined her cheeks.

Flags in the downtown area were lowered to half-mast as the city went into mourning.

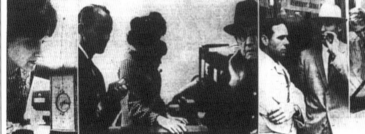

Faces mirror shock in Tulsa as, from left, a clerk hears a news broadcast; the stock market closes at 1:08 p.m.; men confer on the street; Tulsa Daily World wire room is crowded

—*World Staff Photo by Johnny Walker*

Assassination Halts Festive Events

Yule Parade, Games Delayed

Tulsa's 1963 Christmas parade | The downtown event which announced | Santa Claus—was scheduled to | during the early afternoon in respect to the President.
was postponed Friday because of | mally attracts thousands of adults | begin at 10 a.m. |

Loss Shock To Tulsa's Democrats

ALL FAITHS JOIN IN MOURNING

City's Churches to Offer Prayers for Presidents

In 1963, the parade was scheduled for the morning of November 23. However, the day before, on November 22, 1963, Tulsa, along with the rest of the world, was plunged into shock as the news of Pres. John F. Kennedy's assassination began to spread. Out of respect for the president and his family, most downtown retailers closed and the decision was made to postpone the parade as well as several other events in Tulsa that weekend. The parade was moved to the following Saturday, November 30. While the parade still had a festive and fun atmosphere, when the American Flag float, entered by Carson-Wilson Post No. 1 of the American Legion, proudly waved as it passed down the route, seen below on South Boulder Avenue, the *Tulsa World* reported a "reverential hush" overtook the crowd. (Above, courtesy of *Tulsa World*; below, photograph by Howard Hopkins, courtesy of Dewey F. Bartlett Jr.)

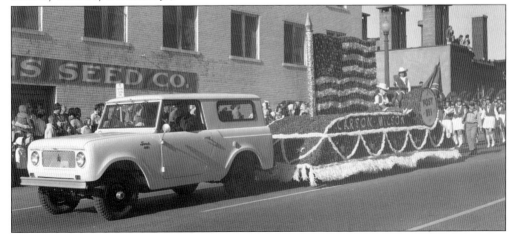

At the 1956 parade, *Tulsa World* quoted twin brothers speculating about Santa: "Gee whiz . . . he has to be everywhere at once. He must be twins like us." Throughout the years, many pairs of twins have come out to make memories together while watching Santa in the parade. Above, anxiously waiting for the December 13, 2008, Christmas Parade of Lights to begin, Jolie and Gentry Kirk, four-year-old twin sisters from Bixby, Oklahoma, push as close to the barricades as possible to make sure they get the best view of the spectacular sights. At left, unidentified twin brothers share a tasty snack as they watch the spectacles of the 1974 Christmas parade float past them. (Both, courtesy *Tulsa World*.)

In 1955, *Tulsa World* titled Santa the "most beloved and believed-in 'entertainment star' " in an article covering that year's parade. At right, two-year-old Lynn Ogilvie sits in Santa's lap while her bashful twin sister Lou, not sure she thinks Santa is the "most beloved . . . entertainment star," runs back to the waiting arms of her mother, Wanda Ogilvie. Below, over 50 years later, Santa is still a beloved entertainment star, as seen on the faces of four-year-old Thaddeus Jarvis and his twin sister Sarah, sitting behind him, as both, bundled warmly, gleefully watch as a float approaches at the Parade of Lights on December 9, 2006. (Right, photograph by Howard Hopkins, courtesy of Dewey F. Bartlett Jr.; below, photograph by A. Cuervo, courtesy of *Tulsa World*.)

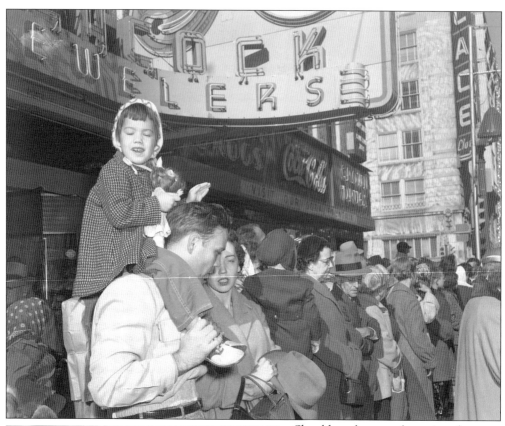

Shoulders always make a nice place to get the best view of the parade for the thousands of children who have excitedly watched during its 90-year history. Above, the crowd gathers under the iconic sign for Peacock Jewelers, at West Fourth and South Main Streets, as a young girl clutching her doll sits on a man's shoulders to get a better view of the 1956 parade. While her eyes are closed, she surely opened them with wide-eyed wonderment as floats and bands made their way down South Main Street. At left, Gary Conroy, trying to stay warm by sipping hot chocolate, offers a seat to his friend's daughter Colby Martinez as they watch the parade at the same intersection of West Fourth and South Main Streets 45 years later, on December 8, 2001. (Above, photograph by Howard Hopkins, courtesy of Dewey F. Bartlett Jr.; left, photograph by Tom Gilbert, courtesy of *Tulsa World*.)

Clowns are a favorite of many children during the parade because they often walk into the crowds and interact with the kids while they are waiting for the parade to start. Seen here, a clown shakes the hand of an unidentified young boy as other children and adults look on, anxiously anticipating the start of the 1970 parade. (Courtesy of *Tulsa World*.)

Seven-year-old Sharlot Fulton, worn out from the 22-block route, catches a ride on the back of a clown at the 1956 parade. The two pass in front of the Skaggs Drug Center, a tenant on the bottom floor of the McFarlin Building, at 3 East Fifth Street, in the 1950s. (Photograph by Howard Hopkins, courtesy of Dewey F. Bartlett Jr.)

 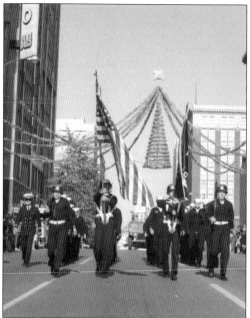

Throughout the years, most parades have started with a color guard provided by different local groups. Above left is a color guard made up of Marine, Navy, and Army representatives at the 1949 parade. Above right, at the 1970 parade, the color guard is made up of Navy Seal cadets. Below, the color guard that started the 2016 parade is made up of members from the Knights of Columbus Fourth Degree Assembly No. 849. They are, from left to right, Ron Thierry, Jeff Kessler, Bryan Jodoin, Toy Lichtenburg, Fred Crump, and Patrick Carrington. (Above left, photograph by Howard Hopkins, courtesy of Dewey F. Bartlett Jr.; above right, courtesy of *Tulsa World*; below, photograph by Stephanie Phillips, courtesy of Tulsa Christmas Parade.)

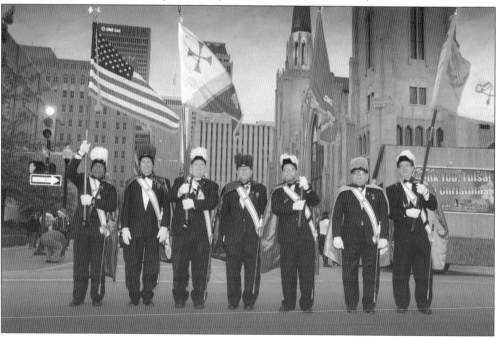

Miss Oklahoma is a frequent guest of honor at the Tulsa Christmas Parade. Seen at right in a Cinderella crystal ball carriage is Miss Oklahoma Kelli Masters at the 1997 parade. Below, Miss Oklahoma Georgia Frazier opted for an umbrella instead of a carriage to keep her dry at the 2015 parade; she is escorted by Pam Cook and driver Ed Owen, a member of the Knights of Columbus. A native Tulsan, Frazier placed in the top 10 at the 2016 Miss America pageant. (Right, photograph by John David Heckel; below, photograph by Brett Rojo; both, courtesy of *Tulsa World*.)

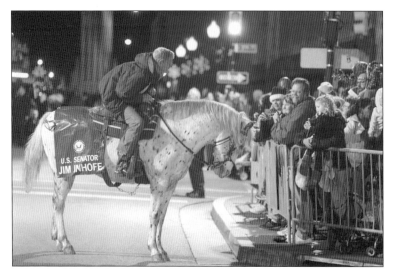

US senator Jim Inhofe greets visitors from his horse, Speck, during the American Waste Control Christmas Parade on December 13, 2014. Inhofe has participated in the parade for nearly 40 years, since he was Tulsa's mayor during the 1970s and 1980s. (Photograph by James Gibbard, courtesy of *Tulsa World*.)

Most of the photographs in this book from the years 1949–1974 are from a collection by Tulsa photographer Howard Hopkins and are generously courtesy of former Tulsa mayor Dewey F. Bartlett Jr., who in 2009 took steps to preserve this collection from being lost. Howard "Hoppy" Hopkins started his career in photography during the 1940s as a combat photographer in World War II. After the war, he worked for a time at *Tulsa World* and then went on to run his own photography company, documenting four decades of Tulsa's history until his retirement in 1989. Bartlett and his wife, Victoria, are seen here trying to stay dry under their umbrella at the 2015 parade. (Photograph by and courtesy of Bland Bridenstine.)

The Tulsa Christmas Parade has entertained millions of people since 1926. Thousands have worked countless hours over the last nine decades to ensure the legend of the Magic Empire is not lost as the great city of Tulsa moves into a second century. At right, drum major Charles Scott (left) and Denise Jaqua (right, with a baton) lead the University of Tulsa Marching Band at the 1949 parade. Below, the Bixby High School Marching Band follows the same route 67 years later at the 2016 parade. In the background of both photographs, buildings along South Boston Avenue that have witnessed the parade since the golden era of Tulsa's early days attest to both the rich history this city has seen each year at the Tulsa Christmas Parade and the bright future ahead for Tulsa in the years to come. (Right, courtesy of *Tulsa World*; below, photograph by Stephanie Phillips, courtesy of Tulsa Christmas Parade.)

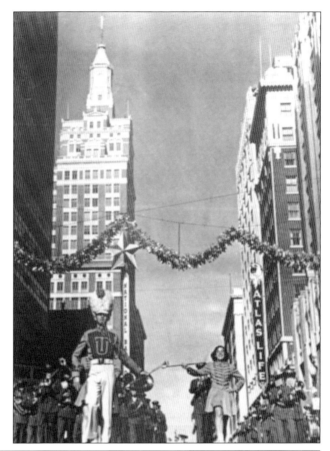

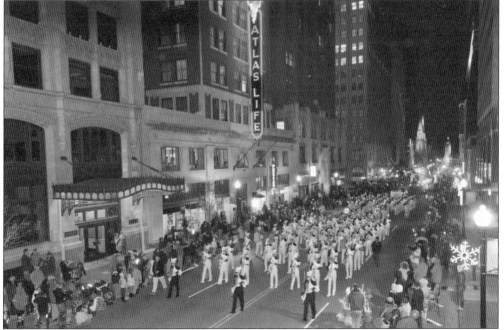

DISCOVER THOUSANDS OF LOCAL HISTORY BOOKS FEATURING MILLIONS OF VINTAGE IMAGES

Arcadia Publishing, the leading local history publisher in the United States, is committed to making history accessible and meaningful through publishing books that celebrate and preserve the heritage of America's people and places.

Find more books like this at
www.arcadiapublishing.com

Search for your hometown history, your old stomping grounds, and even your favorite sports team.

Consistent with our mission to preserve history on a local level, this book was printed in South Carolina on American-made paper and manufactured entirely in the United States. Products carrying the accredited Forest Stewardship Council (FSC) label are printed on 100 percent FSC-certified paper.

MADE IN THE